CHARACTER DESIGN QUARTERLY

CONTENTS

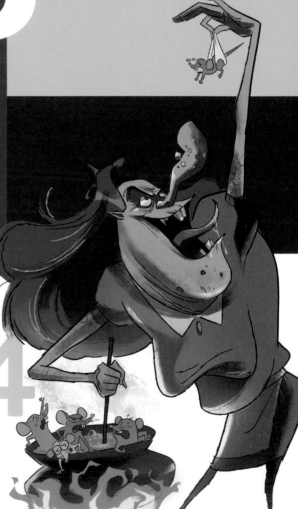

WELCOME TO *CHARACTER DESIGN QUARTERLY 30*

It's hard to believe we've already reached our 30th edition! Over the years, we've had the pleasure of sharing the techniques and experiences of so many talented artists, and this issue is no exception. For *CDQ 30*, we've introduced a few new twists to the magazine, alongside the regular features you know and love.

The gallery feature has been replaced by the development gallery, where we not only get to see some wonderful characters from artists throughout the industry, but now we can also learn how these characters came to be.

We're also focusing on tackling specific aspects of character design. Benjamin Denkert creates a dragon-slaying character with dip pens and then shares a wide range of general tips for the medium. Dan Sprogis shows us how to use the background of your image as a character in itself, and Soyeon Lee focuses on how silhouette and contrast can really push a design.

With a beautiful cover by *CDQ* favourite Noor Sofi and even more tutorials and features, *CDQ* 30 is a fitting celebration of the magazine so far. Here's to the next 30 issues!

**SAM DRAPER
EDITOR**

BEHIND THE COVER ART:
NOOR SOFI

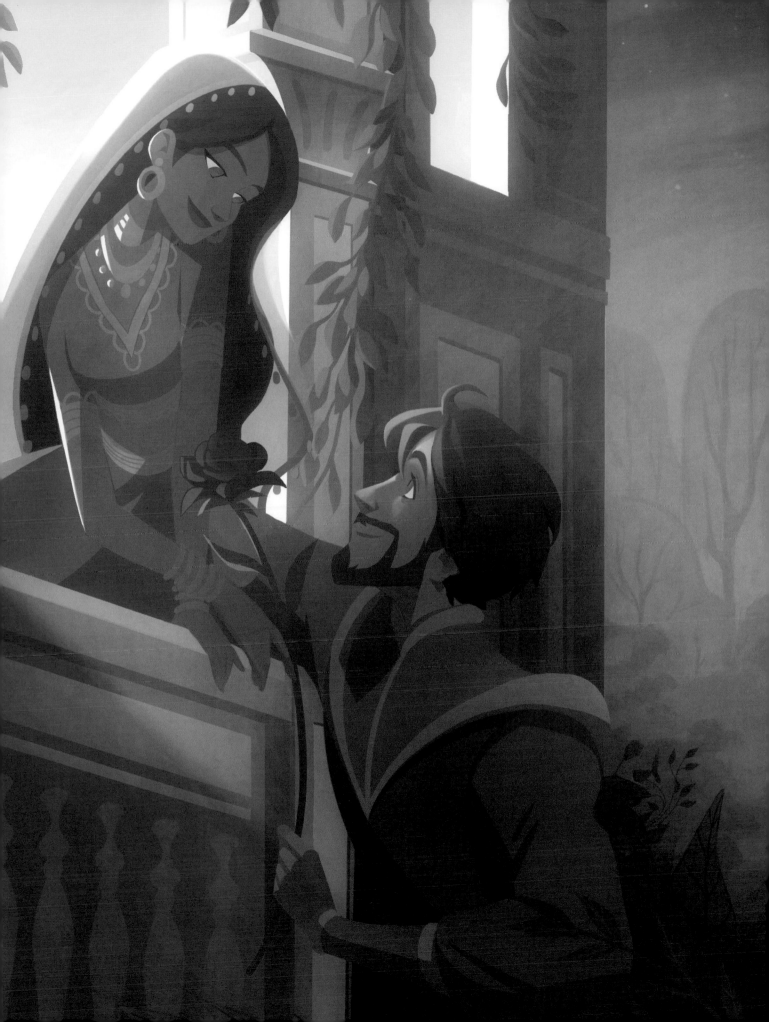

Hi Noor, welcome back to *CDQ*! Can you start by telling us a little about your art journey so far?

I've always wanted to be an artist. I am first generation Kashmiri and I come from a family of doctors and business executives. Besides myself, the only other artist in my family is my sister, and I think we've always inspired each other with new ideas. Growing up, we used to love coming up with stories together and, rather than writing the story out, I really wanted to draw the characters I wish existed in real life. I'm very lucky to have a family who is supportive of my goals. Despite my parents not really understanding how the art world works, they always gave me the freedom to pursue my dreams and never made me feel guilty for choosing a path different from the one they chose.

After college I got a job at the Oscar-nominated Taiko Animation Studios, which is where I currently work. After some time, I was introduced to the publishing industry and started creating children's books. I never imagined myself working in publishing, but I've found the experience very enriching. If I've learned anything about being an artist, it's to keep your mind open to the many possible avenues that could come your way.

What would you say are the key elements of your art style and how has it changed over time?

I think my work has a strong emphasis on lighting and colour. I get so excited at the painting stage of any piece because I love to design the composition of the lighting. As my skills have refined over the years, I think my style has evolved, and I have a more educated and defined approach to designing. In some respects, it has become more simplified, but in other ways, more complex.

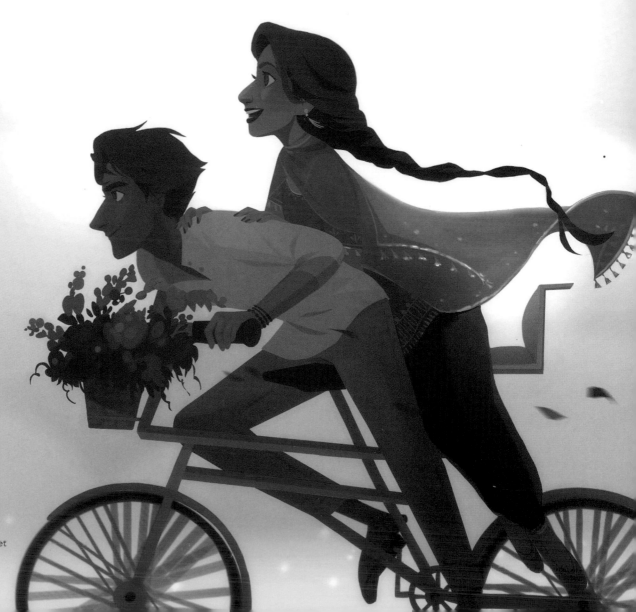

Sunset Bikeride –
A young couple
has a romantic
moment riding
through the sunset

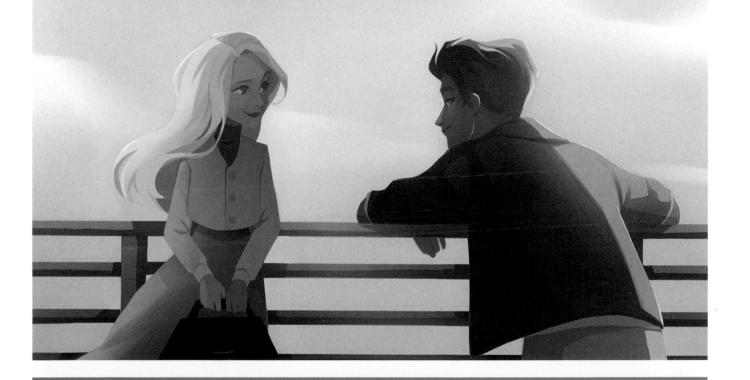

Meet Cute –
A boy and girl have
a chance meeting

'I get so excited at the painting stage
of any piece because I love to design
the composition of the lighting'

How did the opportunity to illustrate children's books come about?

I was actually quite lucky – my agent discovered me on Instagram and reached out to see if I would be interested in illustrating books! Not everyone is able to find an agent so easily, so I'm really grateful. Through her I've been able to work with wonderful clients and create inspiring books.

What's your favourite project you've worked on, and why?

I've enjoyed just about every project I've worked on, but I think my favourite has been *I Can Be All Three*, written by Salima Alikhan. I tried experimenting with some new styles and approaches while making that book and it was so much fun to design.

Who and what are the major inspirations and influences behind your art style?

My inspirations change all the time! Some consistent ones have been Art Nouveau, Mucha, impressionism, old Indian folk art, and classic Disney.

What advice would you give for artists just starting out for turning their hobby into a career?

Practise as much as you can and don't get discouraged if someone is further along than you – we all move at our own pace. What's important is to keep creating the things you wish to see in the world.

What upcoming projects should we look out for?

My first graphic novel with Disney will be coming out in the future – at the moment it's still unannounced, so I can't say much more than that!

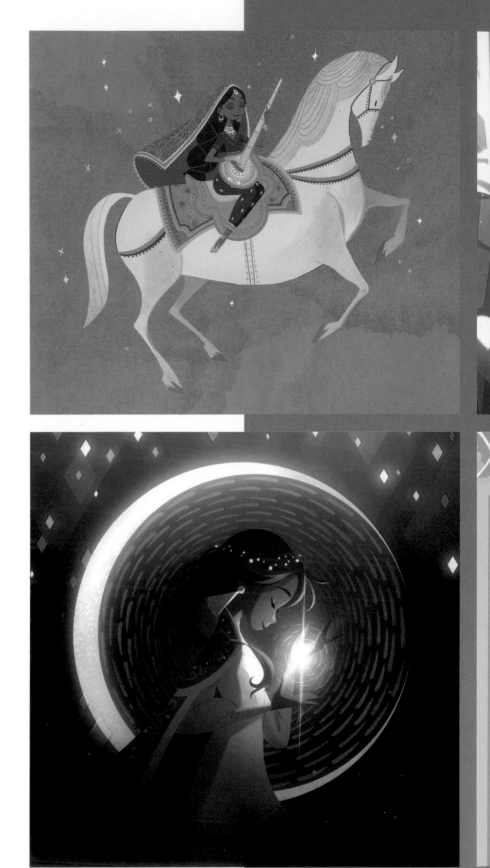

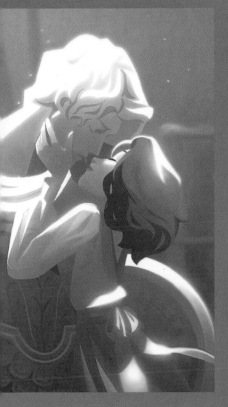

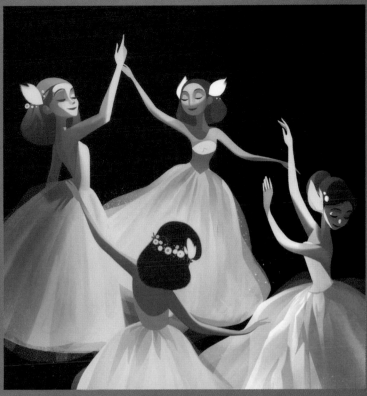

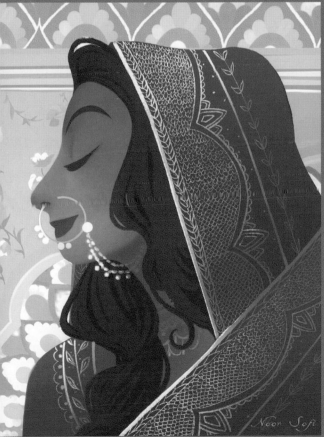

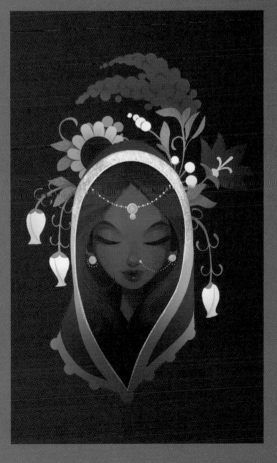

Clockwise from
top left:

Sitar –
An Indian girl riding on
horseback as she plays
the sitar. This piece was
inspired by traditional
Indian folk art

Kiss of Life –
A woman's kiss brings
a statue to life

Ballerinas –
Four ballerinas dance
together, capturing an
image of soft femininity

Flowers –
A beautiful Indian
woman surrounded
by floral elements

Red Bride –
Indian brides
traditionally wear red
to their wedding

Moon –
The moon goddess
watching over her stars

CRAFTING THE COVER

Noor Sofi shows us how this issue's enchanting cover was put together

 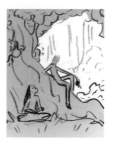 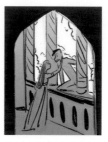

Thumbnail themes

When designing for a cover, you want the image to be an absolute show-stopper! It has got to be something eye-catching and well composed, with narrative elements to draw readers in. We'll start by brainstorming a series of ideas for what this exciting art piece could be. I've already decided that the image will feature a theme of romance, as that's something I enjoy drawing and am known for. Of course, we don't want to box ourselves in, so I also explore other ideas as well. This is the stage where you can be as open and experimental as you wish.

Research and reference

Once you've discovered which direction you want to go in, you can start to do further research and idea exploration for the route you've chosen. I decide to go with a *Romeo and Juliet*-themed cover, but with a Persian influence. As research, I collect references of classic *Romeo and Juliet* balcony scenes, Persian architecture, and clothing. All of these elements will help inform the final piece and bring a defined identity to the scene.

The refined sketch

Once you've finished researching, you can start to compose the final image. It might take several tries to find the right composition. This is the stage that might take the longest, simply because you are setting the foundation for the rest of the steps. You need to have a solid drawing based on correct perspective and accurate anatomy, otherwise the whole piece will fall apart. While working on my balcony scene I also need to keep in mind that this will be a magazine cover and there will be words on the page. I make sure to compose the piece so that the title of the magazine won't interfere with the artwork.

Above: Start off by brainstorming possible ideas for *CDQ*'s magazine cover

Top right: Gather references to help inform and inspire the piece

Bottom right: Create the foundation of your piece by sketching a solid drawing

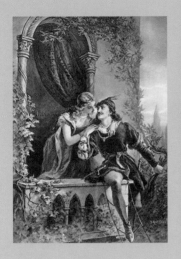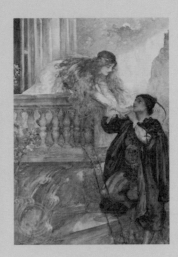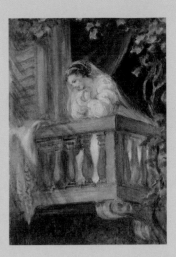

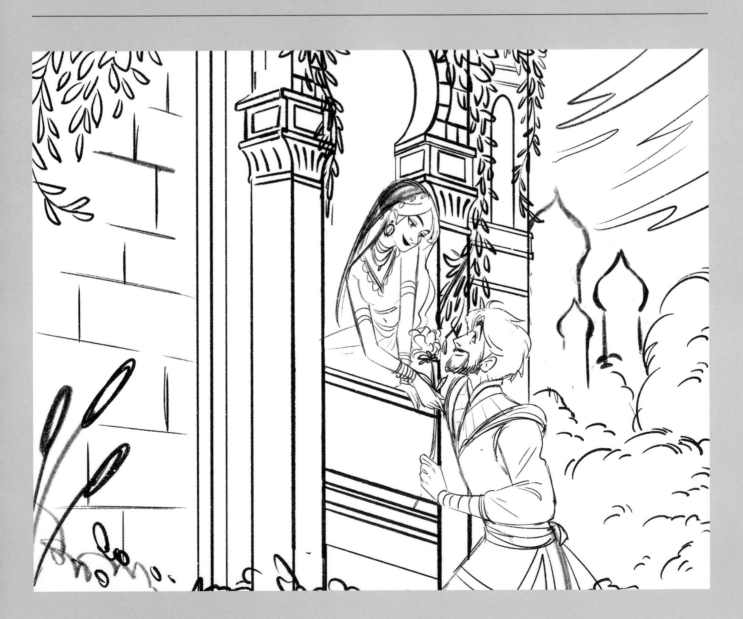

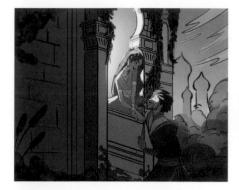
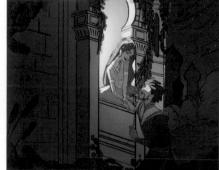
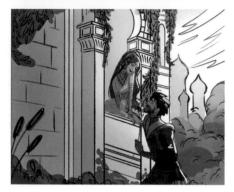
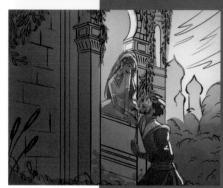

Colour exploration

Before you start painting, it's a good idea to do some quick colour explorations to find the right atmosphere for your piece. I know I want the cover to show a romantic scene, so I want colours that will add to the mood – no rancid greens here! Sometimes, experimenting with placing the scene in different times during the day can help change the mood. For instance, a daytime scene is very cheerful, a sunset scene would be more dramatic and romantic, and a nighttime scene feels secretive and mysterious. In the end, I decide that the nighttime scene is the right fit for this piece, as the balcony scene in *Romeo and Juliet* takes place at night, and the hour gives the piece an air of secrecy and excitement.

Changing plans

As you continue to develop the piece, you will notice certain things that you like and certain things you don't. It's important to listen to your instincts and add or take away from the piece as you see fit. In the original plan, the window Juliet was looking out from had no specific design elements, but as the piece develops, I think that adding patterns and colour to the architecture seems necessary to give the scene a stronger identity.

Above: Try different colour schemes to see which colours capture the mood of your piece best

Right: Build upon your piece by listening to your artistic instincts

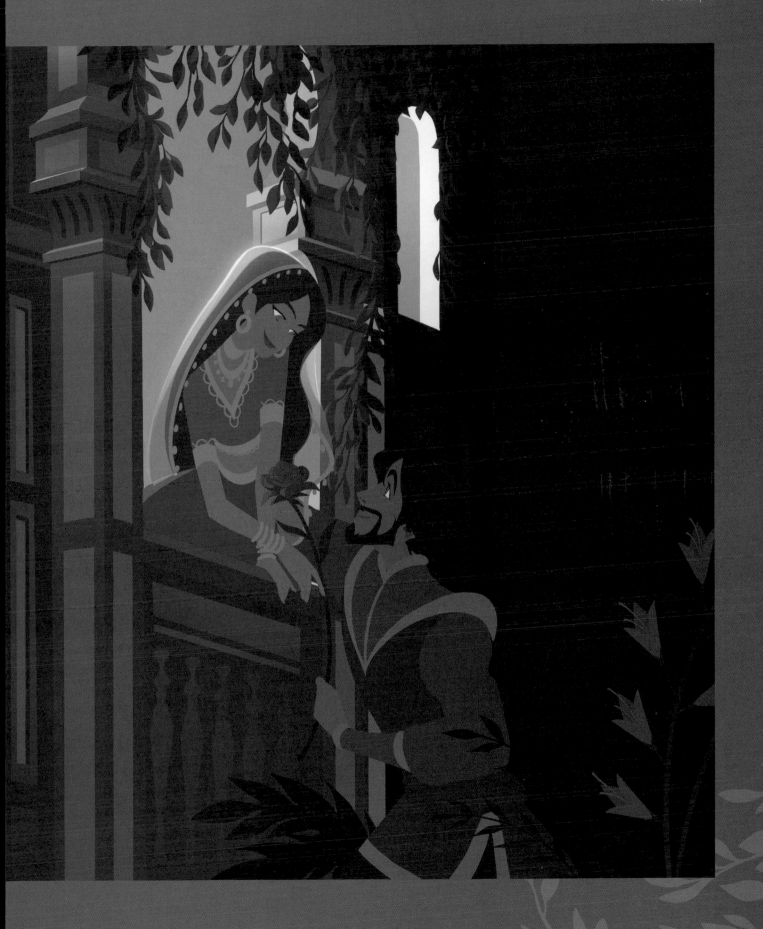

Lighting the night

Once you've laid out all of your colours, now comes the exciting part where you get to add the drama of lighting. Lighting can really add a lot to a piece – it can help communicate story, add ambience, and guide the viewer's eye. Because this scene takes place at night, lighting is a definite necessity that will make the piece work. I use the light spilling from inside the house to highlight Juliet and catch Romeo's expression. I finish off with a few final touches and colour corrections.

Finish your piece by adding in any lighting or necessary final touches

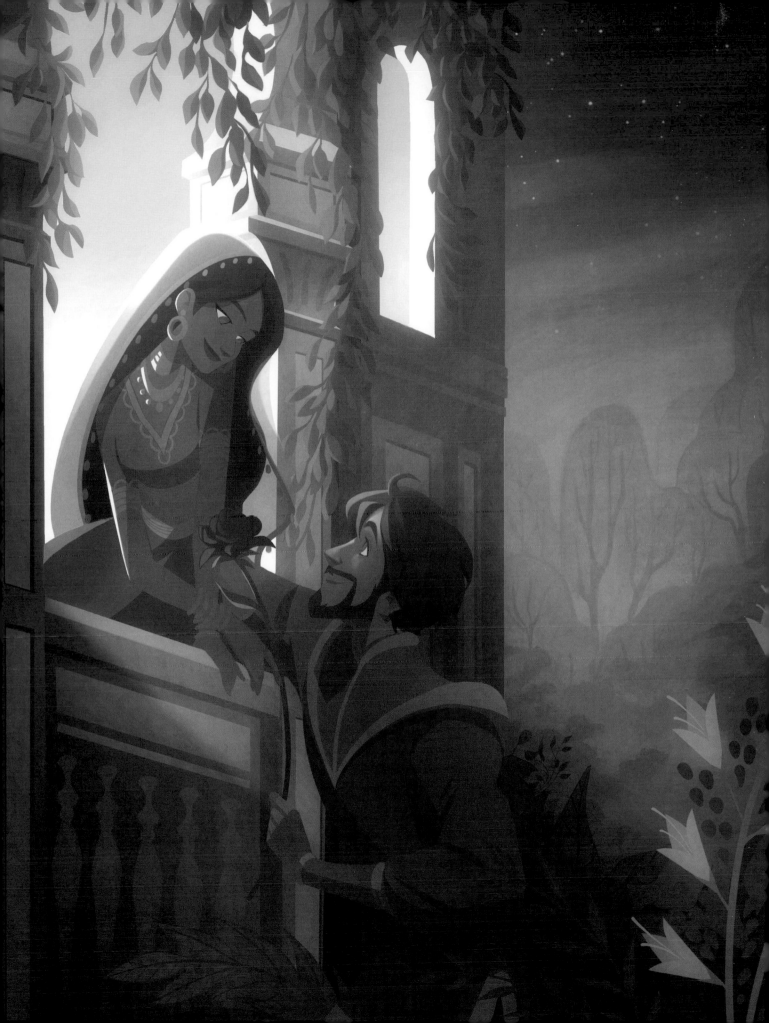

Night turns to day

Sometimes when working on a project, a drastic change might be needed, even a long way through the process. The goal here was to create a cover image for *CDQ*. After finishing my original version, I realized that the final artwork of the scene at night may be too dark to print properly onto paper. Dark images, while beautiful on screen, can be difficult to translate onto the page, as dark colours can often get lost and blurred during the printing process. As a result, I made the choice to experiment with a different time of day: dusk. It's a romantic time, and visually brighter.

I think this new setting brings something new to the piece and to the narrative – this is still a romantic moment between the two characters, but there's also a visual brightness that works well for printing. Alternating to a different time of day meant adjusting the lighting on the characters and the colour harmony. While the original had a strong contrast of blues, purples, oranges, and yellows, this one has a harmonious analogous colour scheme of orange, pink, purple, and a pop of green. The lighting now comes from the sun, rather than from inside the building, which completely changes the direction of the light – it now comes from behind the man and catches his sweetheart's face.

And with that, this eye-catching cover is finished!

The final cover image, with a new light source and time of day

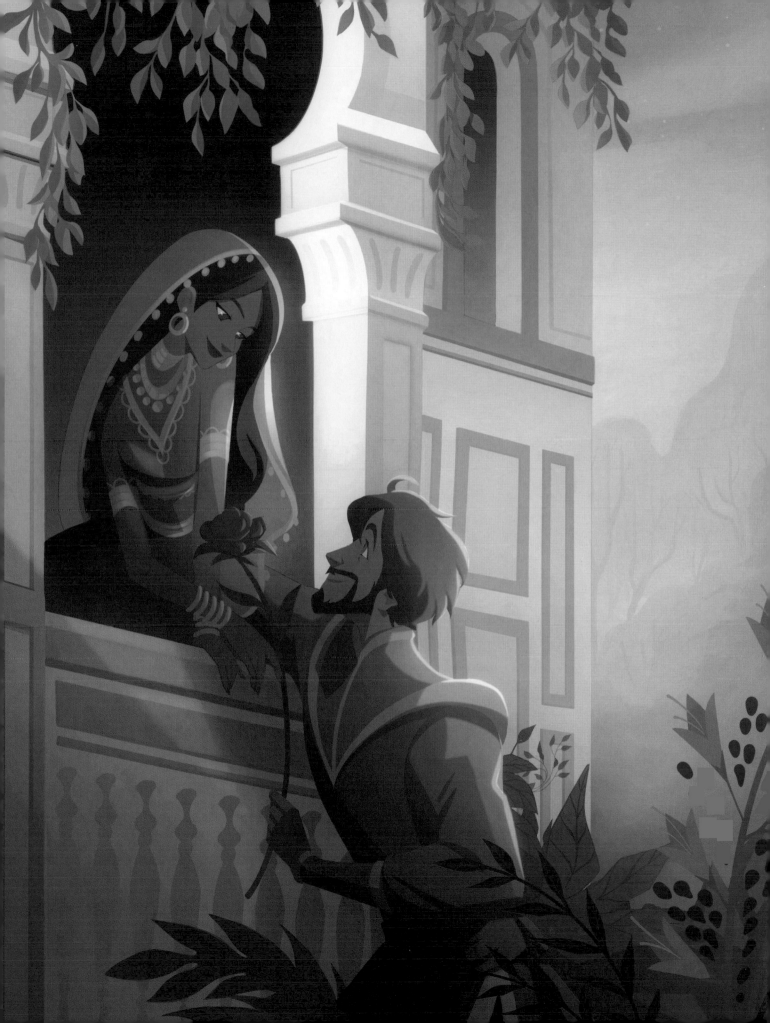

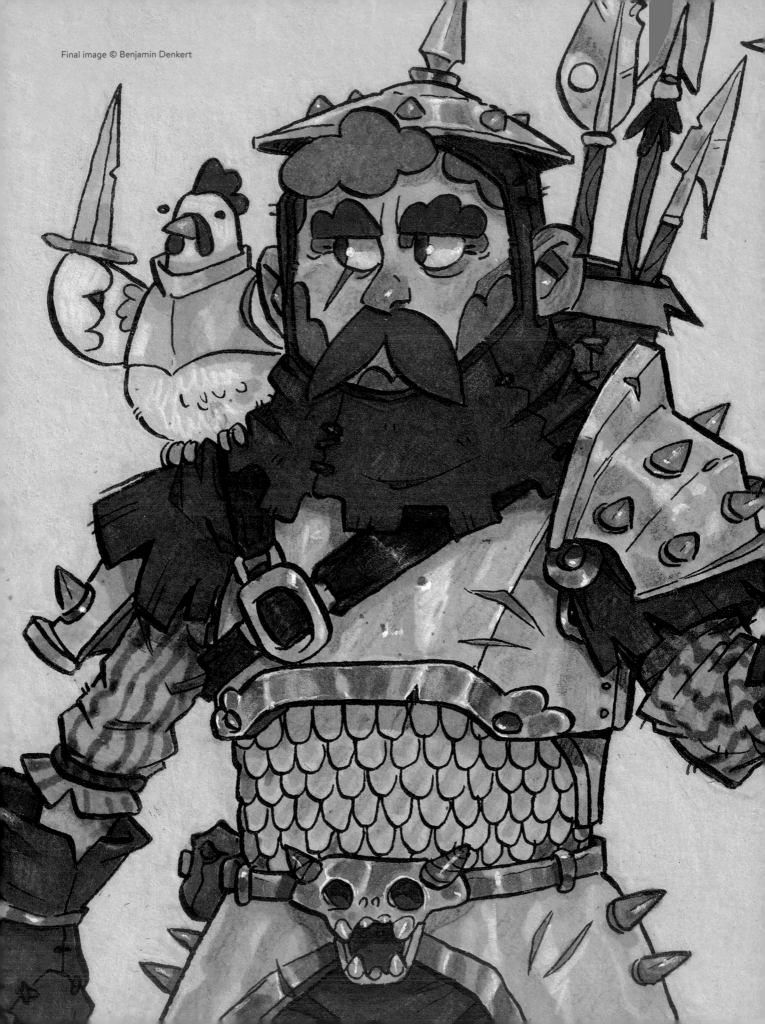

The Dragon's Tale

Benjamin Denkert
uses physical
media to create
a Norse-inspired
dragon slayer

Let's get started

In this tutorial we will go through the process of designing a new character, Egdir the Dragon Slayer, working from the prompt 'The successful dragon slayer returns'. We will be utilizing associative and explorative techniques to iterate our finalized concept, and then finish up a more elaborate sketch using mixed analogue materials. The focus will be on ink and markers, but simultaneously, we will throw a few coloured pencils and different papers into the process. For the most part, our progress will happen on paper, with the small exception of some notes and colouring tests so as not to strain our sketchpads.

Finding inspiration

We usually work with references and well-researched visual libraries in a production setting, but for this character, we will give our accumulated inner pool of associations and inspirations a try. In the first step, we take the prompt and see what our heads can bring to the table. This early stage allows us to see what our minds can conjure up and to work through any wild ideas and impulses that we might think of. Create as many doodles as you like, exploring the thoughts that the prompt inspires. Don't be scared of making these sketches wild and messy! Aim for flavour, not presentation.

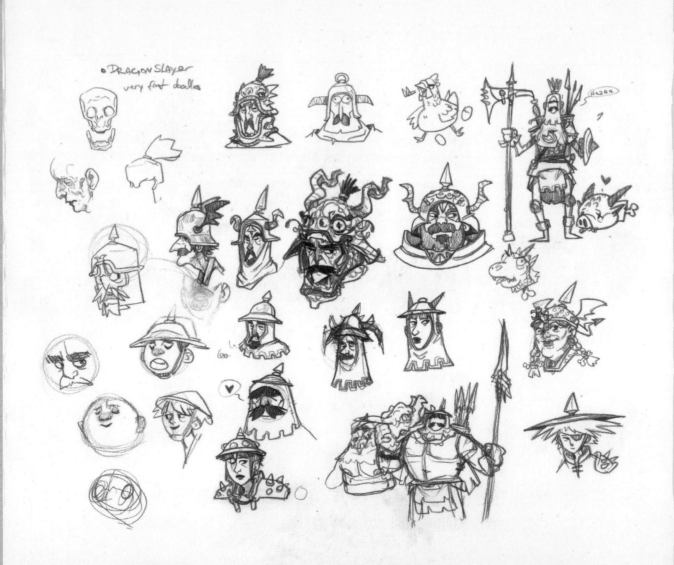

Start with doodling to get the mind flowing

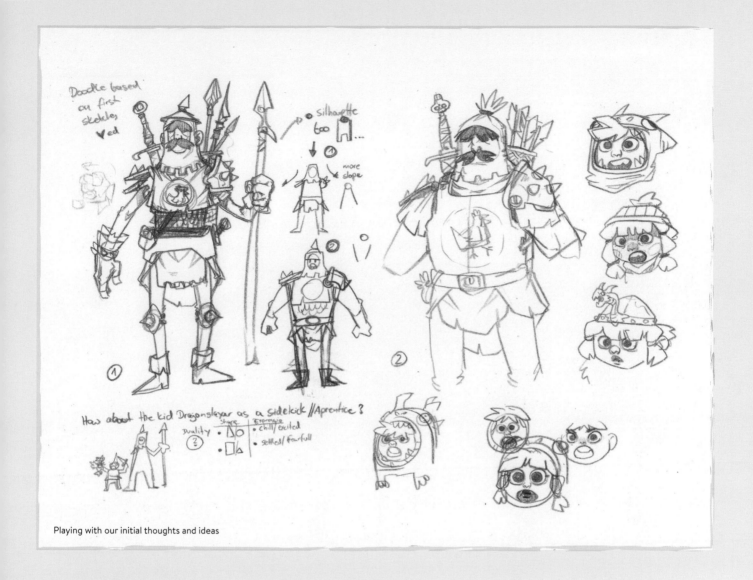

Playing with our initial thoughts and ideas

'Add some detail and shape your ideas, thinking about additional features that serve a purpose or just add more nuance through narrative'

Building on sketches

Now take some of the ideas that might look and feel like they could have potential and elaborate on them. Mark the sketches that you like on your first page and keep them in mind – I mark mine with little hearts. I start by working on an over-burdened knight with slim legs. He's agile and compensates for a lack of strength with a large arsenal of weapons. Add some detail and shape your ideas, thinking about additional features that serve a purpose or just add more nuance through narrative. I start playing with the idea of a sidekick, like a little dragon-hunter apprentice, to give the main character a contrasting dynamic. We're still early in the process, so keep it light, fun, and even goofy. I definitely work best when I amuse myself while designing.

Further sketching required

This process won't be linear. Sometimes a doodle hits the mark, sometimes the prompt needs to marinate on the paper. I allow time to play with all the ideas we threw down in the first rough doodles, recombining ideas from the first drafts. I work with another of the marked sketches from the first step. I make my knight a little sturdier and more cubic to contrast with his dynamic sidekick. Keep asking yourself if this is still an idea that you find interesting and think others would, too. I think about the prompt again – maybe we can include a trophy from the dragon the knight has slayed? I explore if this can work with multiple quick sketches. These doodles will help us to identify challenges, such as readability and composition potentially suffering. For instance, if the knight is carrying a dragon's head, then his silhouette will be harder to read. Some small doodles to explore how we could integrate the dragon and how it could work might be in order.

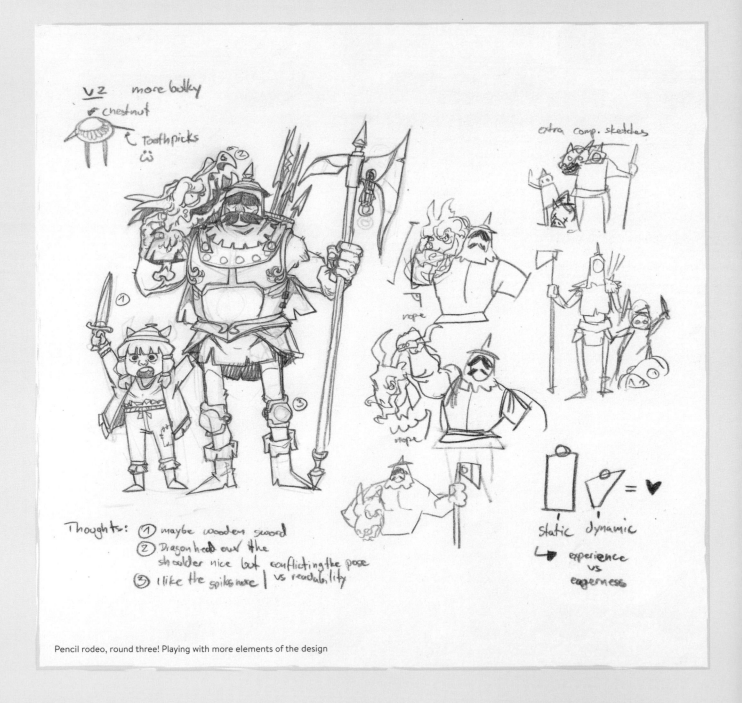

Pencil rodeo, round three! Playing with more elements of the design

'We could make our dragon colossal or comically small, but fierce – both would give the storytelling a unique spin'

Doodling dragons

Now let's take a little detour into the fine craft of sketching dragons! Just like we did before, we explore some of our early doodles further, recombine them, and add new things. The chicken and duck emblems I added to the chest of an earlier dragon hunter make me think of creatures that may have evolved from the chicken family. We could make our dragon colossal or comically small, but fierce – both would give the storytelling a unique spin. I'm also fond of my pig-nosed dragon sketch. A nimble and agile hunter like ours wouldn't be able to carry the large dragon that he just defeated, so I think sticking with showing the dragon's head is our best choice to visualize his success.

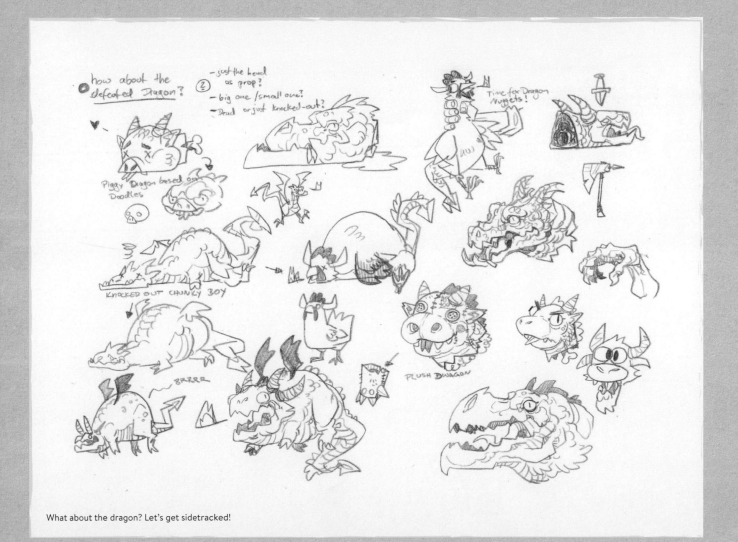

What about the dragon? Let's get sidetracked!

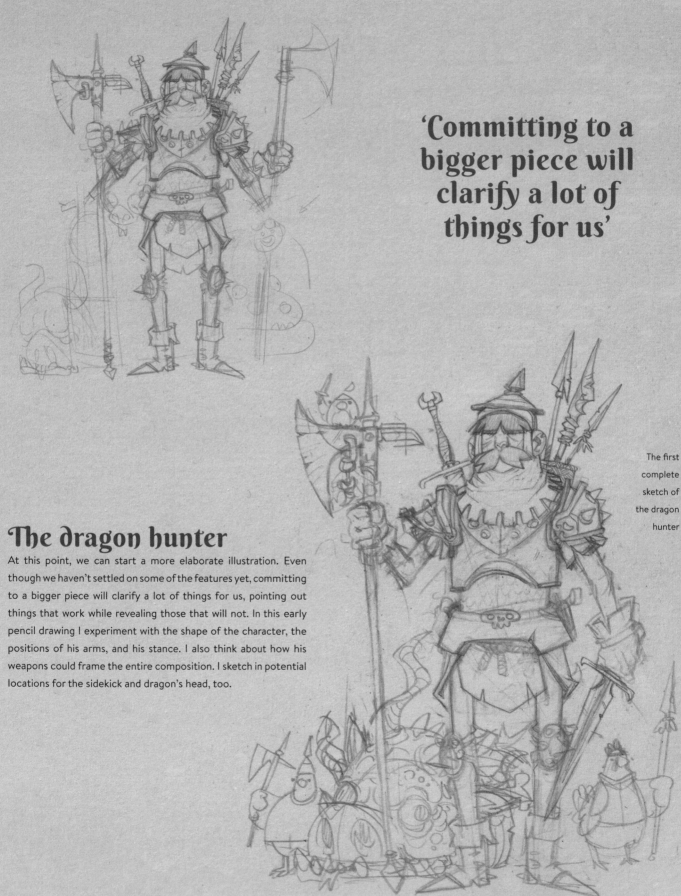

'Committing to a bigger piece will clarify a lot of things for us'

The first complete sketch of the dragon hunter

The dragon hunter

At this point, we can start a more elaborate illustration. Even though we haven't settled on some of the features yet, committing to a bigger piece will clarify a lot of things for us, pointing out things that work while revealing those that will not. In this early pencil drawing I experiment with the shape of the character, the positions of his arms, and his stance. I also think about how his weapons could frame the entire composition. I sketch in potential locations for the sidekick and dragon's head, too.

Inking the sketch

Next, I grab my dip pens and start inking. I decide on dual weapons, a dragon trophy, and no apprentice for the final sketch of my dragon slayer. I want to avoid overcrowding the image – but do you remember the chickens? As I'm drafting the sketch, they re-emerge and take on the role of a little gang aiding our hero on his adventures. Now that there are clearer lines, we can better judge which elements might need some more thought. The dragon's head looks interesting, but creates lots of visual noise. The character is still rocking a rather bulky, well-protected torso, and slender, agile legs. Wielding so many weapons while fighting big armoured fire lizards certainly requires the ability to move quickly – providing him with maximum range of movement in his arms and legs is a possible way to go here.

Safety first

Before you colour anything digitally, do a safety scan of your finished sketch, with just the line art. Some inks will not scan well when you transfer your paper sketch on to the computer – having this separate version can be a great help later in the process.

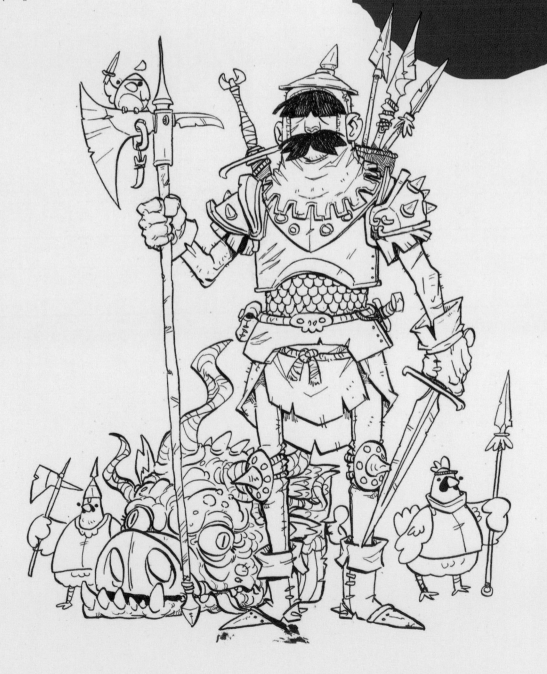

Inking the lines lets us see what we have so far

Colour evaluation

Alright, we have a draft we can work with, but before we take it apart, let's give it some colour. We could grab our markers and test our colour combinations on a piece of scrap paper or make some separate colour sketches. However, it's already noticeable that there are some design problems, so I just pick some colours I feel comfortable with and start colouring the dragon slayer. I add a little background behind him to check if the silhouette blends in or remains readable. This will, of course, affect our colour scheme.

Identifying issues

With a first colour pass of our character complete, we can look at our piece and analyse the things that don't work. Firstly, I notice that the beard and bangs that cover his facial features draw very little attention to the face. The highly detailed dragon provides too much contrast to this area. The direction of the spears, axe, and the sword on the character's back also pull the observer's eyes away. The audience's gaze now either wanders all over the upper part of the image or gets pulled down to the dragon.

I spot another problem with the left-hand sword, which awkwardly intersects his leg. The lower-right part of the image feels separated from the rest, causing our little chicken to be appear quite lost. In short, there is too much noise in the lower-left of the image and nothing to act as a counterbalance. Well, back to the drawing board – let's fix things!

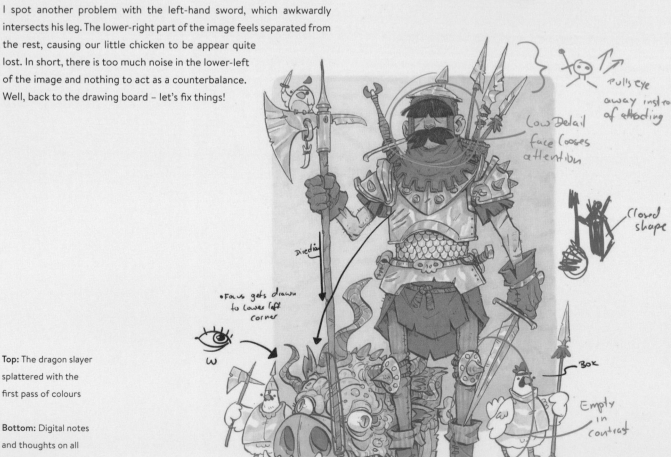

Top: The dragon slayer splattered with the first pass of colours

Bottom: Digital notes and thoughts on all the issues I identify

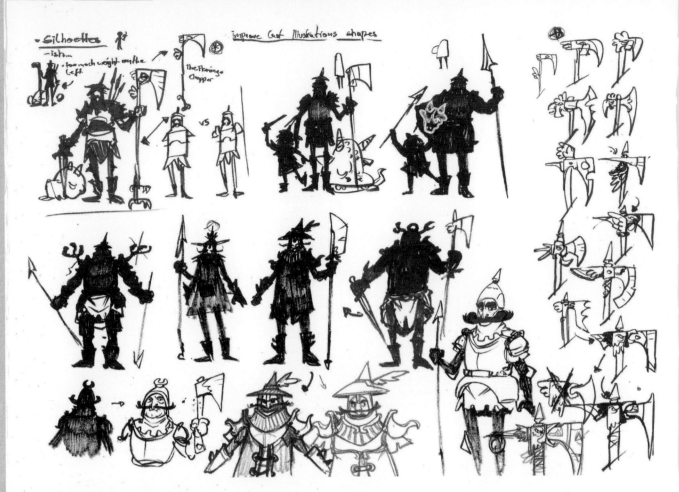

Silhouette doodling. Let's make some shapes!

Taking a step back

One great way to check readability is with silhouette doodles. Taking a step back from the more complete sketch lets us address some of the issues we've identified so far. We can even consider revisiting the entire design, reintroduce ideas we had earlier, or find new things that might have been unclear so far. I haven't really given much thought to the weapons yet, for instance, so I try out different design ideas for his halberd, in particular.

Starting with silhouettes

Silhouette doodles are also a great way to start the entire process of creating a character. In this instance, it would be useful to articulate the purpose of the character first. Is the character meant for a game or animation? In what kind of environment will the character be, and how will their shape and features affect readability in said environment? Maybe we're designing a third-person character where a player will mainly watch the back of the character? Ask yourself these questions, and get doodling!

Replace the face

At this point, why don't we try some different materials and work with paper once more? I want to address the lack of detail in our character's face and spend some time considering the colours. His non-existent eyes may convey a certain mellow attitude or even confidence, but the hero and his chicken squad just returned from a victorious hunt – slaying a dragon isn't a mundane task, so perhaps a sterner expression might be more appropriate? I throw some new faces onto the paper and ink them. This paper is slightly tinted, so it's harder to predict how the colours will behave. As much as I like the goofy sixth face, I decide to move forward with faces two and three.

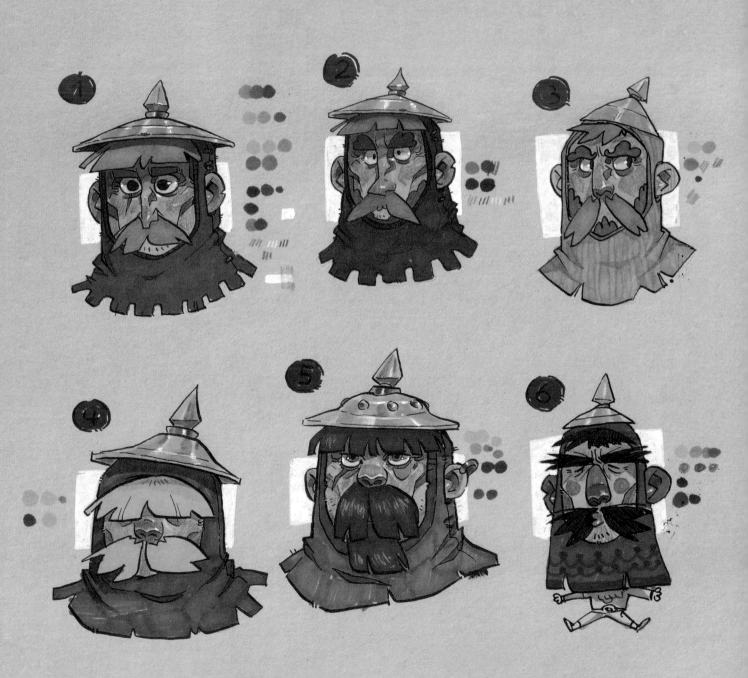

Testing some new faces and playing with alternative materials

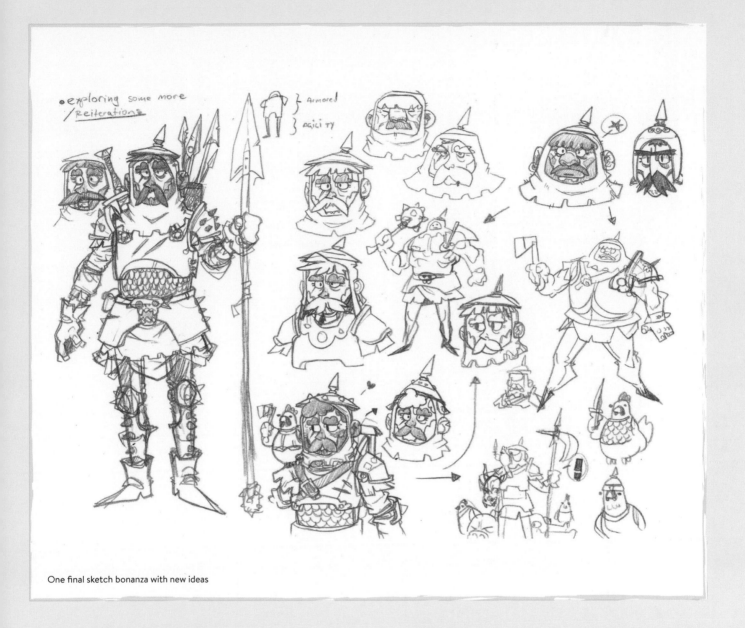

One final sketch bonanza with new ideas

'I add little doodles addressing the composition of the overall image, incorporating my new ideas'

Solidifying the design

Great, more sketching! Let's assess the ideas we gathered in the last two steps. I settled for a more open face, so it's time to incorporate that into the overall design. I mark the sketch that seems the most intriguing with a heart once more, but also remain open to incorporating elements from the other versions. After burning through some ideas and making sure

I'm comfortable with the direction the design is going, I add little doodles addressing the composition of the overall image, incorporating my new ideas (marked in the image with a little exclamation mark). Of course, we can't forget to add our little chicken helpers! At this point, we have enough to start our final design and a more elaborate piece.

What's in a name?

This is a great moment to talk about the thought process behind naming our characters. My first impulse was to think of David, the slayer of giants in biblical mythology, but other inspiration arrives from an unlikely source. Earlier in the process, I added the little chicken helpers, and as I draw the final sketch, I end up with exactly three chickens alongside our hero. As it happens, we can find three giant roosters in Norse mythology that herald the arrival of Ragnarök after the great dragon Nidhogg starts gnawing on the world tree Yggdrasil's roots. Two of these roosters are called Fjalarr and Gullinkambi, yet the third one is unnamed.

Even more of this old Norse tale fits our design: Fjalarr notifies Eggthér (or Egdir), a herder, of the impending end of the world. A dragon, three chickens, and a herder? Even though I've established a more medieval look in my design, it's still quite fantastical, so the Norse myth is a great source to pick names from – and Egdir sounds great! Since we are missing a third name for our roosters, how about a bit of fun: Nugget, Hotwing, and Drumstick? Or we cam play with the sound of a rooster in different languages: Kikeriki, Kukeluku, and Cocorico ('chicken' in German, Dutch, and French). That works!

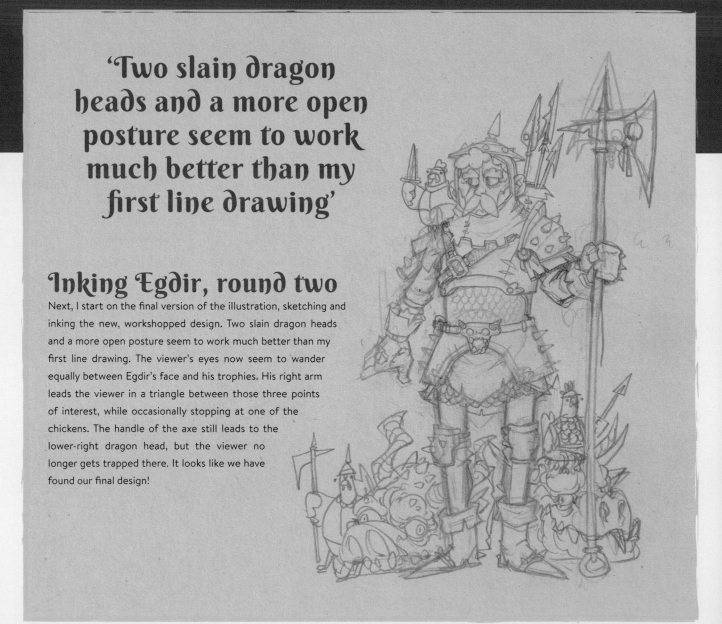

'Two slain dragon heads and a more open posture seem to work much better than my first line drawing'

Inking Egdir, round two

Next, I start on the final version of the illustration, sketching and inking the new, workshopped design. Two slain dragon heads and a more open posture seem to work much better than my first line drawing. The viewer's eyes now seem to wander equally between Egdir's face and his trophies. His right arm leads the viewer in a triangle between those three points of interest, while occasionally stopping at one of the chickens. The handle of the axe still leads to the lower-right dragon head, but the viewer no longer gets trapped there. It looks like we have found our final design!

Sketch and inking stages of the final illustration

Safety second

I take another safety scan before moving on to colouring. The scanned lines will come in handy in two ways: this time, we will invest some time to make digital colour sketches over the scan and, as mentioned earlier, marker-safe inks tend not to scan well.

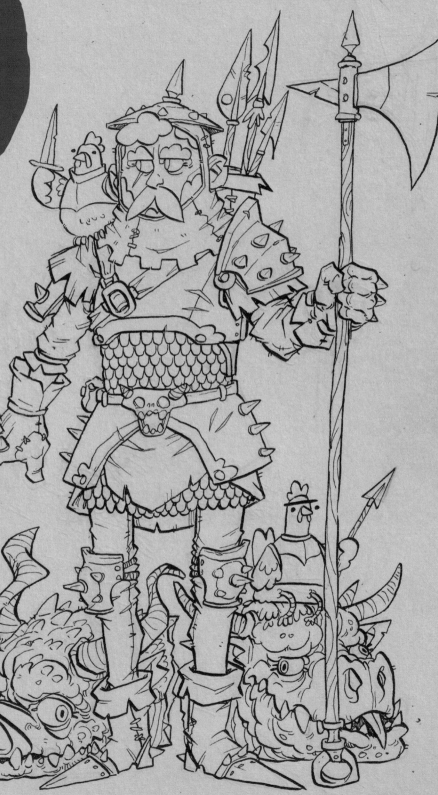

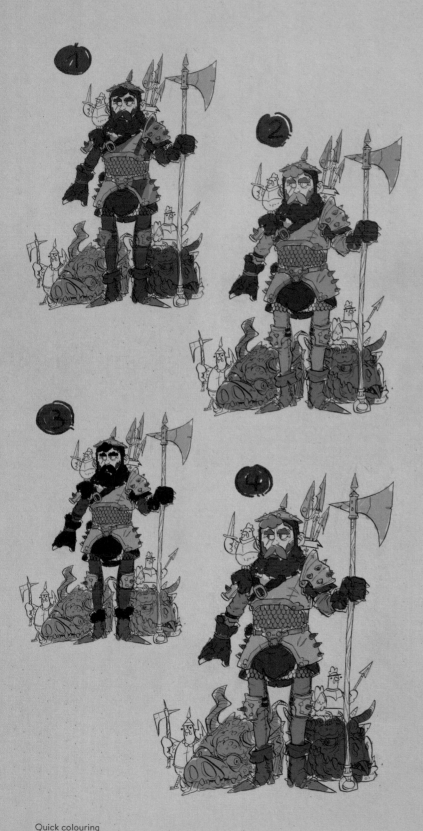

Quick colouring tests to find the right palette

Finding the colours

Working completely on paper can be daunting – there is no Ctrl+Z to undo your mistakes! As you work more with markers, you build up a pool of experience to draw from, but in this case, I chose to work with paper I wasn't familiar with. I have some idea of what will work from the colour test faces I drew earlier in the process, so I take my scan and combine it with my final line drawing. Digital colours will not translate to our markers directly, but we can get a good approximation and we can always test our markers on a piece of scrap paper.

I create four different colour schemes for Egdir. I think image four reads the best: the purples seem noble, while not stepping too far into the realm of crazy disco armour. The other versions seem a little too bland in comparison and make Egdir look more like a henchman than a hero. His orange hair is also a nice counterbalance to his armour, without being a complete contrast, so let's go with these colours.

Introducing Egdir and the gang

It's time to finish our Dragon Slayer Egdir and his band of fierce combat chickens, Kikeriki, Kukeluku, and Cocorico. Let's look at the final design and how everything fits together. I gave the dragon heads a more monochromatic colour which further helps to move the viewer's gaze around the drawing. Egdir's face is a clearer focal point now. The left shoulder guard gave way to one of the chickens to enhance the focal point around the head area. In a fight with a dragon, it makes sense to have the leading shoulder protected and have the other free to move and guide the halberd, or to throw a spear with full force. His arms and legs are less exposed, yet they remain agile and free. And finally, the blue background acts as a minor contrast to his hair and beard colour. We've finally found our perfect dragon slayer!

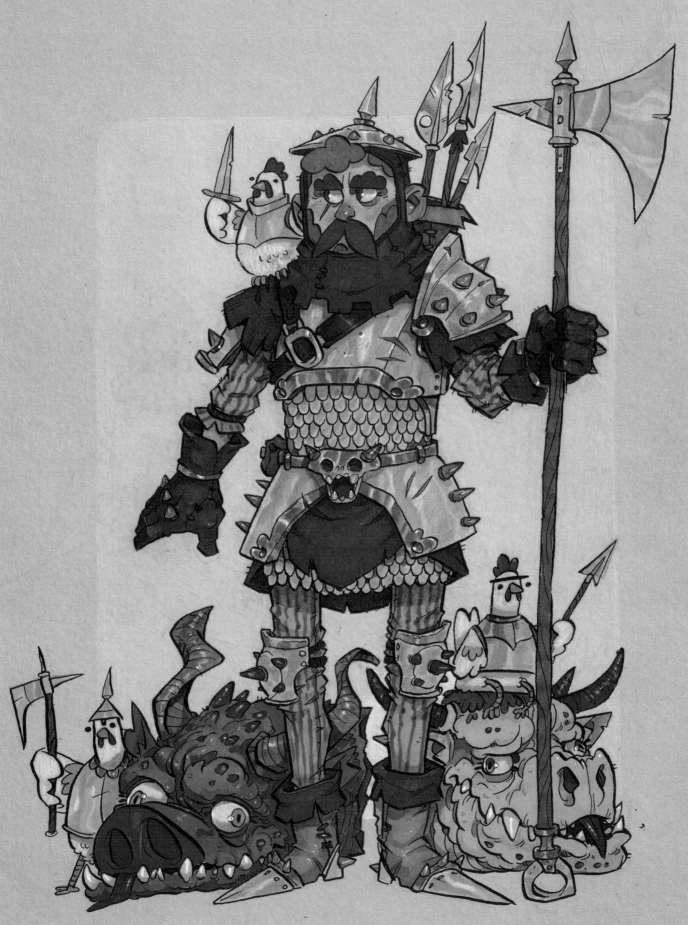

Working with dip pens

Dip pens are a great way of using ink to add depth and texture to your character designs. However, getting used to working with a physical tool can be tricky, so let me share with you some great tips for getting the most of out of your dip pens.

Burning your nibs

When working with dip pens, there are a few things we should do to ensure that they work properly and won't become a nuisance. First, we burn our nibs, whether the pen is new or you haven't used it for a while. The first burn gets rid of any factory coating that was used to protect it, the second burn incinerates any oil or residual ink that might be left from your last session.

Removing graphite

Removing the graphite from your lines before inking will lead to a smoother experience. To do this, take a kneaded eraser and form a little sausage. Roll it over your drawing with a light amount of pressure to pick up some of the graphite, dust particles, and eraser bits. Your lighter lines will now be significantly easier to ink.

Creating soft transitions

Creating soft transitions between colours can be a challenge if you aren't blessed with a set of 500 markers. One way would be to use a marker and rely on it to blend in with the new layer being applied on top. We can also use colored pencils and put a light shading where we want that transition. Coloured pencils do blend, but they don't spread out when drawn over with a marker.

The perfect contact

Indenting the paper by applying too much pressure can cause your nibs to get caught or the marker ink to be soaked up. So, we make ourselves a flat pencil by taking a regular hard pencil and grinding the tip down to a roughly 90 degree point. This gives us a larger contact surface with the paper while drawing. 3H to H are great choices for pencil hardness, depending on the grid of the paper.

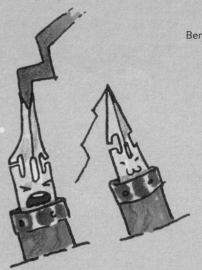

Test and learn

Learning to use drawing nibs has a bit of a learning curve – they require a certain sensitivity and control, but that makes them a great tool with a lot of variation. Take the time to test the nibs to get familiar with their quirks. How much do they flex? What is the maximum line weight, and what's the finest line we can produce? With most nibs, you can only draw with a pulling motion, but a well-made nib will allow you to push without puncturing your paper. This is a fantastic way to create very fine lines. Turn the nib upside down if you want them even finer.

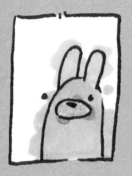

Trial and error

Nothing is more discouraging than having thrown down a great pencil sketch, only to discover the ink or marker colour is spreading out as soon as we apply it. There are great recommendations on the internet for papers and inks, but those won't always translate perfectly to your own experiences. Only through trial and error will you discover what works best for you. For instance, I used to dislike watercolour until I purchased my first good-quality watercolour paper. Since then, it has been one of my favorite tools to create art with.

Mix your media

Markers are a great tool for making lines, but they can be quite a crude tool sometimes. Mixing media can help with adding subtler lines – use coloured pencils to add details, blend, and make patterns after using markers to put the local colours and shading in place.

Liven up your lines

Lines made with drawing nibs are naturally livelier and more characterful than lines made with a felt-tip pen or a fine liner. Depending on the style we choose for our work, we can enhance that effect and make our lines more organic by adding some variations, like small gaps, tiny points that intersect the lines, and so on. This is also a great way to communicate surface structure.

We always want to avoid unpredictable and uncontrolled lines. Apart from learning how to control our nib, regular cleaning during the inking process can also help. A dip pen only holds a small amount of ink that dries rather quickly. Every few dips, we should wipe our nib with a damp paper towel to avoid build up. Dipping into clean, distilled water before plunging into ink helps some inks flow. Some people even poke a potato with their pen every few minutes.

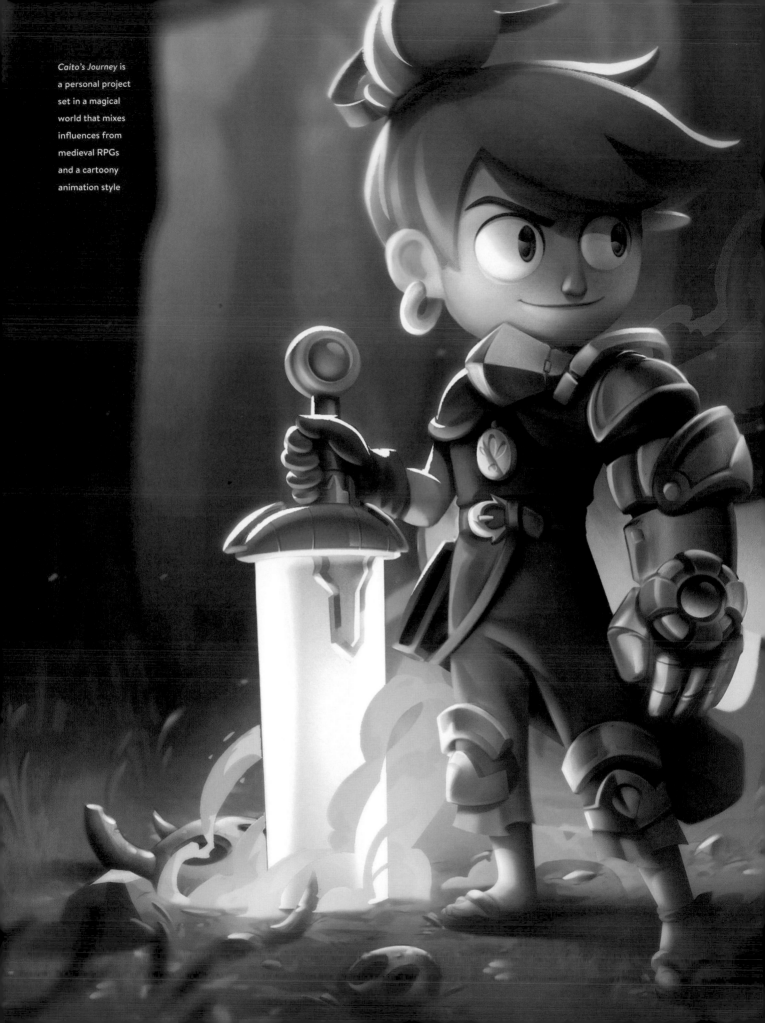

Caito's Journey is a personal project set in a magical world that mixes influences from medieval RPGs and a cartoony animation style

MADBOOGIE
CREATIONS

Amanda Duarte, partner and creative director at Mad Boogie Creations, tells us all about the studio's work and design philosophy

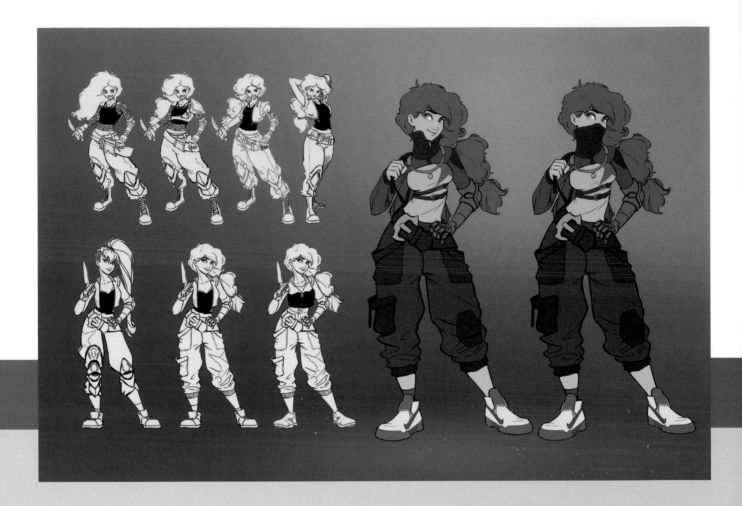

Thanks for taking the time to chat to *CDQ*! Can you tell us a little about the studio and how it got started?

Thank you for this opportunity! Mad Boogie is an outsourcing art studio, specializing in creating visual content, especially illustration and visual development in games, animation, and editorial, for many companies all around the world. Gus Lima and I started the studio working from a home office in 2011. There weren't a lot of full-time opportunities for this type of work in Brazil at the time, so we teamed up to work as freelancers from home. Our first clients were local advertising agencies and indie game companies. After a few years, our dedication to keep learning and proactively networking started paying off. Attending leading art schools and focusing our portfolio, going to major art conferences, and connecting with industry professionals led us to our first international clients. This was our first big breakthrough, but the real game changer came around 2015, with a shift in focus to social media putting us on the map, and attracting larger clients that aligned more with our style and interests.

With the increased demand of work came the decision to scale up. We transitioned from a two-person team to a more interdisciplinary group of artists, including illustrators, character designers, comic-book artists, and animators. The addition of Julio Cesar (known as MZ09 online) as a partner and art director also helped bring the studio to the next level.

Today, Mad Boogie is a collaborative hub for teams that range from 10 to 20 people, working for major brands like Disney, Bethesda, Marvel, and Adobe, and developing original projects. It's fair to say this surpasses what Gus and I could have ever imagined happening!

How many people work at the studio, and how many different projects do you have generally have on the go at once?

We currently have twelve artists on staff. That includes me as a creative director, and Julio and Gus as art directors, plus an account manager, and project manager. We're working on four client projects and a comic book for one of our original IPs.

This page and opposite: Visual development of Jules, the main character of our original cyberpunk project, SCRAPPED

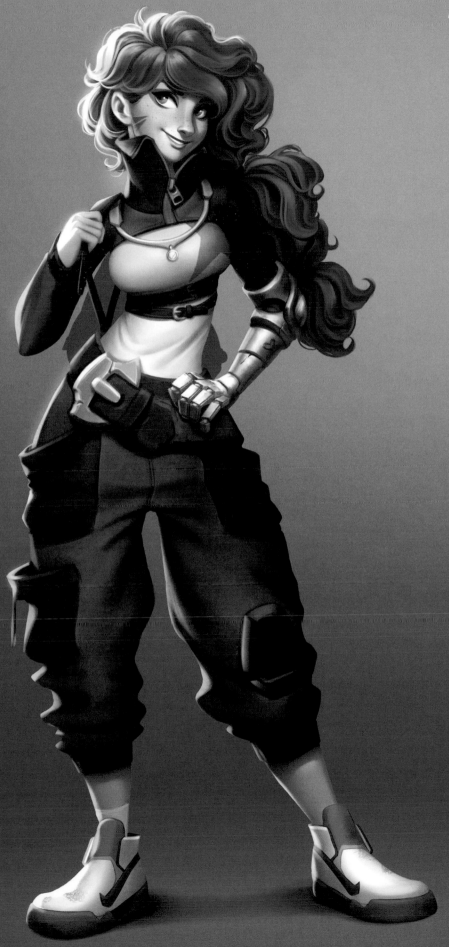

A personal illustration, mixing
graphic stained-glass elements
and a futuristic character

Character development made
as a celebration of reaching
60,000 followers on Instagram

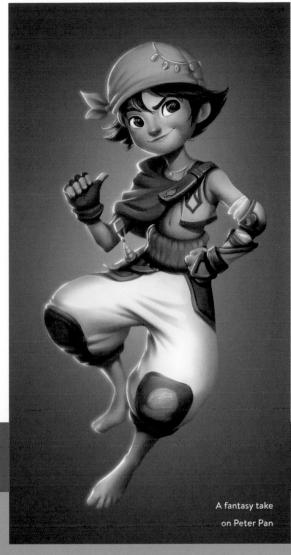

A fantasy take
on Peter Pan

How do you decide which projects you want to work on?

We try to keep a balance between work that genuinely excites us, aligns with our style, and makes financial sense. Some projects are more routine but help us keep the lights on, some are pure creative fuel but have more of a limited indie budget. Then there are our personal IPs, that bring no immediate income but are investments into our creative visions and stories. We're lucky to currently have a diverse portfolio that keeps us financially sound and growing, while also tackling a range of very fulfilling projects.

What are the challenges that arise from working with big, existing IPs, like Marvel and Disney?

Sometimes, high-profile brands come with very specific style guides, and the main challenge becomes being technically accurate without sacrificing creativity. It's easy to make things boring or stiff when you're too worried about being correct. A great example of this push and pull are our card illustrations for Disney *Lorcana* Trading Card Game by Ravensburger. We had to make sure their characters were meticulously on model, while reinventing designs and outfits within specific guidelines, putting them in engaging compositions and dynamic poses, and weaving the specific *Lorcana* aesthetic through everything. It's an intricate process, but seeing our work with such iconic characters out there, and receiving positive feedback from both the client and the audience, has been incredible!

What do you consider the most important elements of character design?

First and foremost, a character must be relatable and engaging. Being aware of the technical aspects is also essential, especially when working commercially within certain pipelines that go beyond the design. For example, in 2D animation, characters might need to be simplified due to budget and time constraints, or a mobile game might require fewer details due to polygon count and screen size.

But no matter what limitations are imposed, if you manage to create a memorable design that inspires curiosity and connects with the audience, then you've done a good job.

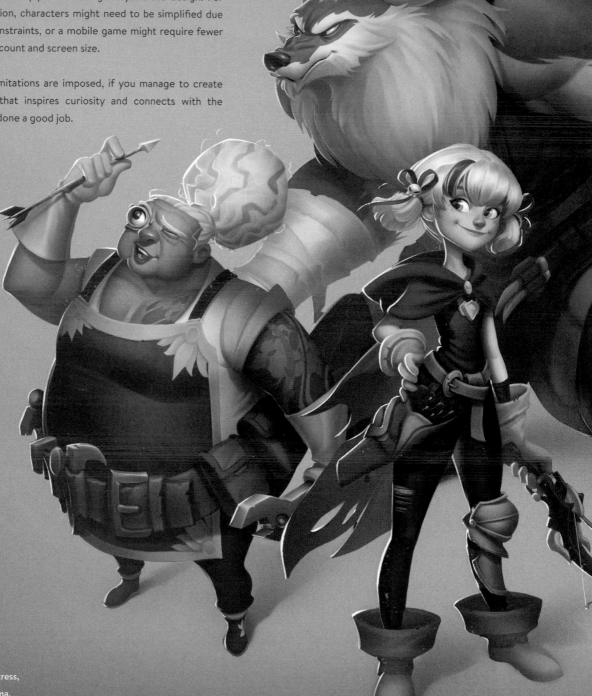

Little Red Riding Hood
reimagined as an RPG huntress,
with her blacksmith grandma,
and the big bad werewolf

EMPLOYEE PROFILE

Name: **Julio 'MZ09' Cesar**

Job title: **Partner and Art Director**

Education: **Bachelors in Advertising**

Website: **instagram.com/mz09art**

Best bits of job:
The flexibility of being able to work from home
on creatively exciting projects

Challenges of job:
Reaching new clients – and having to work with difficult ones!
It's also a struggle to constantly reinvent yourself, updating your
portfolio and social media, being aware of what the market is
currently looking for, and trying to adapt to that demand.

What advice would you give to budding character designers?
Study a lot. If you can, invest in classes, or look for free
or accessible lessons online. Be open to feedback, and
remember to be kind. Networking goes a long way.

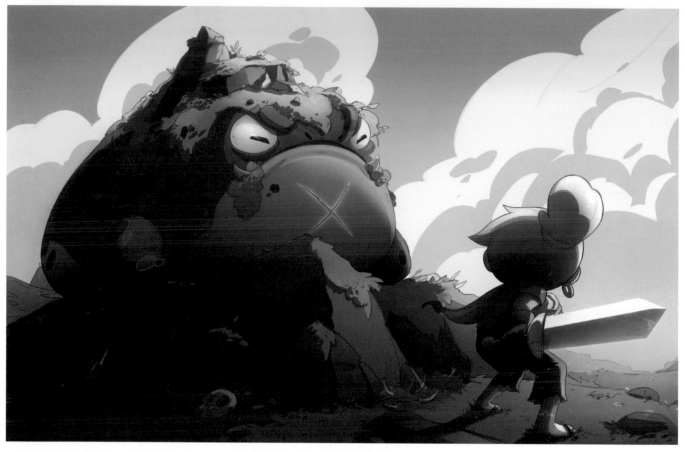

A key visual study of what a battle in *Caito's Journey* would look like, heavily inspired by video games

What character design projects are you most proud of?

Caito's Journey, a mix between western animation and JRPG, is a big favourite. It began as a study in new styles and evolved into a major original IP, now signed with an international production company for adaptation into a comic book and TV series.

Creating a 'space girl' character for Adobe was also a lot of fun. We had complete creative freedom to design a character for their celebration of Photoshop's 30th anniversary, and the result was a 'Draw This in Your Style' (DTIYS) challenge, with hundreds of entries.

But maybe the most unbelievable project of all was reinventing Disney characters like Jasmine, the Fairy Godmother, and Mickey Mouse for *Lorcana*.

What's the best bit of advice you can give to a young artist looking to work at a studio like Mad Boogie?

Aligning your portfolio with our style and technical quality is key, while also being able to offer something unique. Most applications we receive don't quite match our style or are still in very early development, which is not a deal breaker per se, as long as you're open to direction and feedback.

Don't forget the importance of soft skills, too. Good communication, teamwork, and ethics are just as crucial as your ability to draw and paint. Talent in these areas are a very good way to stand out.

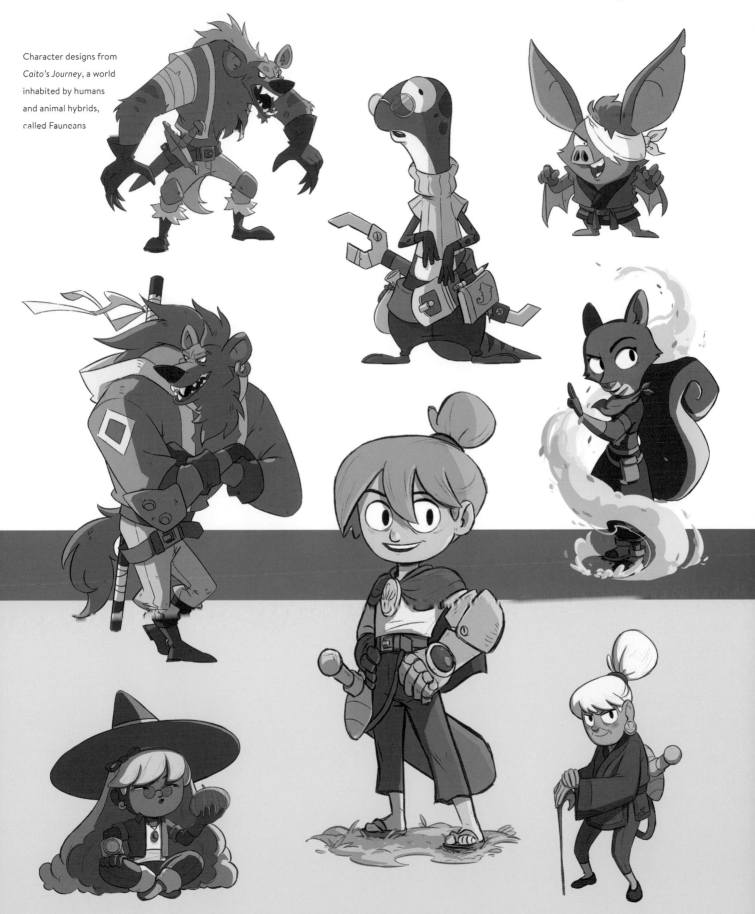

Character designs from *Caito's Journey*, a world inhabited by humans and animal hybrids, called Fauneans

Visual development of an original character, practising dynamic poses

What is it like working in character design in Brazil? Is there a large community of artists?

The market nowadays is very different than it was back in 2011. There are way more opportunities in game companies, studios and agencies, and there are more schools focused on specialized training to prepare students for the industry with strong portfolios.

Of course, the freelance route continues to be a viable option, using the internet and social media to develop an international reach while working from home. The lower cost of living in Brazil compared to the US or Europe is also definitely an advantage. The community continues to grow, both in the number of talented artists, and in collaboration and support. Brazil is a burgeoning market that's constantly growing.

Thanks for talking with us! Are there any upcoming projects we should be looking out for?

Thank you so much, it's been a pleasure! We're very excited about the *Lorcana* expansion trailers we've been creating illustrations for – it's our first foray into animation for a major client, in collaboration with We Are Royale. Our first comic book is also in the works, telling the story of *Caito's Journey*. We're super excited for you all to see everything!

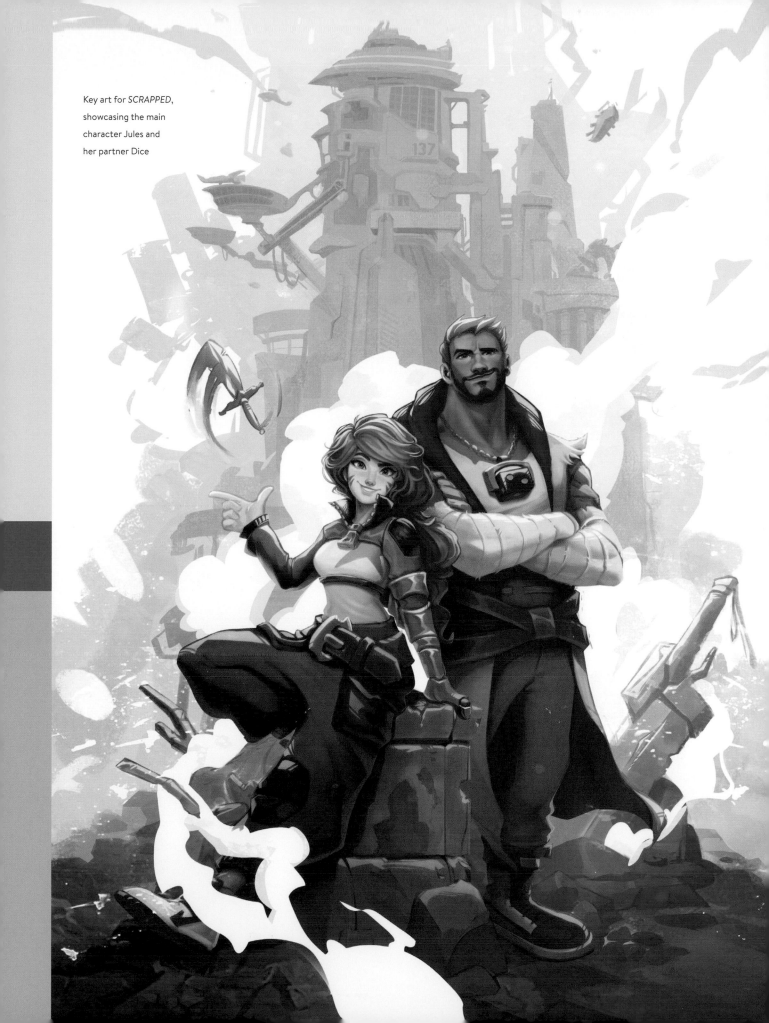

Key art for *SCRAPPED*, showcasing the main character Jules and her partner Dice

MAGE-ICAL MOMENTS

Amanda Duarte from Mad Boogie Creations shares an example of how characters are created at the studio

THE ADVENTURE BEGINS

Join us as we create a stylized, original character – a young mage, named Torrin, who specializes in elemental magic, and is about to embark on her first adventure in a fantastical world. We'll highlight the structured process of character design, including silhouette, sketching, and colour palettes, looking at how each step should shape a character's unique personality and backstory.

CRAFTING SILHOUETTES

Begin by creating distinctive silhouettes, focusing on strong, recognizable shapes that describe your character well. Experiment with different shape languages. At this early stage it's important to work quickly, without worrying too much about details.

LOOSE SKETCHES

Pick your favourite silhouettes and develop loose sketches from them, playing with proportions and features to capture the character's personality and define the style you're going for.

ADDING DETAIL

Refine your sketches, making final variations on details such as clothing and expression, cleaning up the forms for the final line work. At this point, you want to pick the definitive option you're going to go with.

LINES AND COLOURS

Clean up the final line art, then block in base colours. The final palette should reflect the character's backstory and mood, and harmonize well with other relevant characters within the narrative.

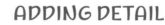

POSES AND EXPRESSIONS

Exploring various poses and expressions helps to visualize the character's range of emotions and movement. Each character will move and express themselves differently, depending on their personality.

LAYER EVERYTHING

Working with multiple layers that separate elements such as line art, colours, and shading, allows for non-destructive edits and easier adjustments throughout your process.

COLOUR THEORY FOR CHARACTER DESIGN

Knowledge of colour harmony and how to combine complementary, analogous, or triadic colour schemes is incredibly helpful when defining a colour palette for your character. Also, contrast is key to leading the eye – a vibrant detail among muted colours will visibly pop out, as will a light value among darker surrounding elements.

THE FINAL DESIGN

Bring together all the elements from previous stages and finish your design by adding lighting, visual effects, and details for a presentation-ready character.

And we're done! I hope this has been helpful in showing that character design is not a hit-or-miss process, but a deliberate series of choices that comes from experimentation.

All images © Mad Boogie Creations

DEVELOPMENT GALLERY ONE
MARGANA

The one thing I consider 'special' about my art style is the texture that I add. I think it's the final touch that makes my illustrations look hand crafted, even though they are digitally drawn. When I draw, I usually have in mind what I'm about to sketch, but sometimes I start drawing simple lines and geometric shapes to find inspiration. I love colouring as it's when I can disconnect from thinking too much about the process – the pose is balanced and the character's proportions look correct, so the colouring can become an 'automatic' step. I always try to give my best to each and every illustration I work on, even when I'm not completely satisfied with it at first.

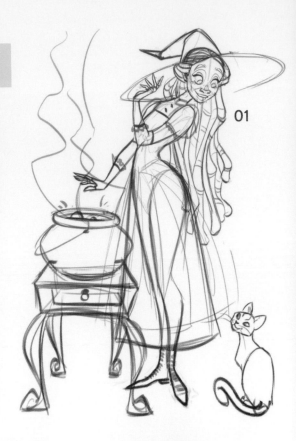

01

01. I usually start sketching using the figure-drawing technique, which consists of dividing what I'm about to draw into simple geometric shapes that help position the elements on the canvas.

02

02. Once I have the sketch ready, I choose a colour palette (or sometimes two) and use it to colour the different parts of the character. If I find a colour doesn't quite fit the character, I try another until I get the desired outcome.

03

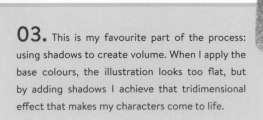

03. This is my favourite part of the process: using shadows to create volume. When I apply the base colours, the illustration looks too flat, but by adding shadows I achieve that tridimensional effect that makes my characters come to life.

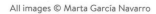

04. The last step of my process is adding textures and details, and special effects such as the smoke in this illustration.

04

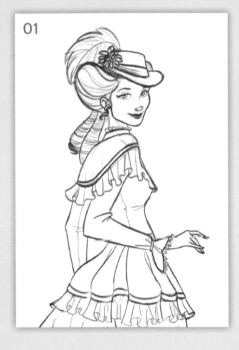

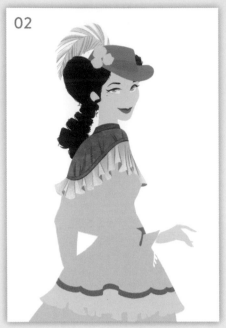

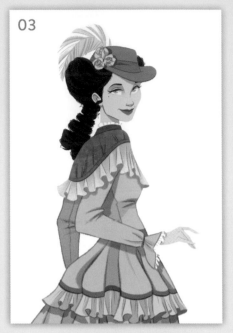

01. The sketch is cleaner in this case because I intended to keep the linear tone in the final piece. I dedicated more time to polishing edges and erasing dirty lines.

02. I wanted the base colours of this character to be broken and not too saturated. I usually apply very bright colours, but on this occasion I tried something different to make my process and style a little less repetitive.

03. I love how shadows give depth to the dress in this example and how they also separate planes – the right arm is the foreground, the torso the medium plane, and the left arm is the background. Overlapping elements always brings more tridimensionality.

04. I decided to erase some of the line art, but kept almost all of it on the attire to distinguish all of the separate parts. The colour of the character's skin and the ornamental feather of the hat required a darker tone for the background, so both skin and feather stood out.

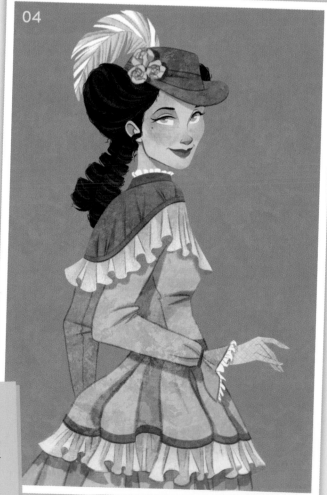

01

02

03

04

01. With this character I wanted to draw with a more tonal style by making the character curvy, but with thin ankles and tiny feet to make her look more adorable, and compensate for her expression of disgust. To keep the pose balanced, it's important that the back of a character's head never exceeds the heel of the rear foot.

02. When choosing the colour palette, I start by choosing the colour that will stand out the most - blue in this case. I then use colour theory to choose the other colours based on that initial selection. In this case, the chocolate-brown colour of the character's skin (warm) combines perfectly with the blue of the dress (cold).

03. Once again the shadows separate the different parts of the character's body and make comprehending the shape much easier. In order to create credible looking characters, no matter the style, gravity and weight are essential details to take into account.

04. When I draw full-body characters I like to add a shadow at their base to make them look like they're standing on a surface, not floating. In this case, I chose a dark blue to create more contrast between the white of the hair and apron, and the background.

WHICH WITCH?

Soyeon Yoo shows us how to push a character design using silhouette and contrast

THE FIRST PASS

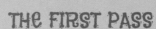

Here is the first pass of a witch character, boiling up rats in her pot! In this early version, the scale of the witch and the pot don't have too much in the way of size contrast, so the design feels a bit flat. Making the size differences more pronounced will help push the design further.

PUSHING CONTRAST

I try to push the contrast much more compared to the first pass. The size difference between the two is working much better now, but I feel as though I can do more with the witch design. I push the proportions of her facial expression and give her a much bigger nose, arms, and hands to make her even more dynamic.

EXAGGERATING THE DESIGN

I revise the witch's design again to give her a more natural pose, especially in the way she stirs the pot and picks up the rat. I exaggerate the witch's facial and body proportions, giving her a bigger bust and a bigger jaw. Also, I further reduce the size of the pot of rats, making the witch look even larger and scarier.

THE FINAL TOUCHES

For the final pass, I think that some of the elements can be better placed on the character's form, specifically how the nose, eyes, and lips sit on her face. I balance the length of her arms and change the position at which they join her torso.

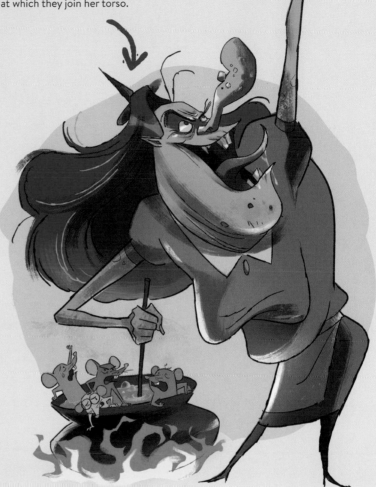

DISPARATE DESIGN

In this breakdown of the contrast between the two elements, you can see how increasing the disparity in size with each pass led to a more effective final image.

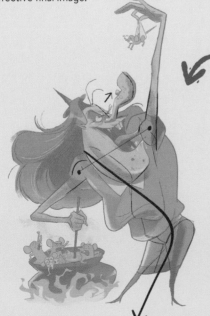

THE LINE OF ACTION

In this structure breakdown, you can see how the witch's eyeline matches up with the rat in her hand, where the pinpoints for the arm placements are, and how the body is placed along the line of action.

BREAK IT DOWN

To understand how the structures of characters work, it helps to break them down into blockier, brick-like shapes first. It's much easier to check for correct proportions when looking at overlaid, simpler shapes.

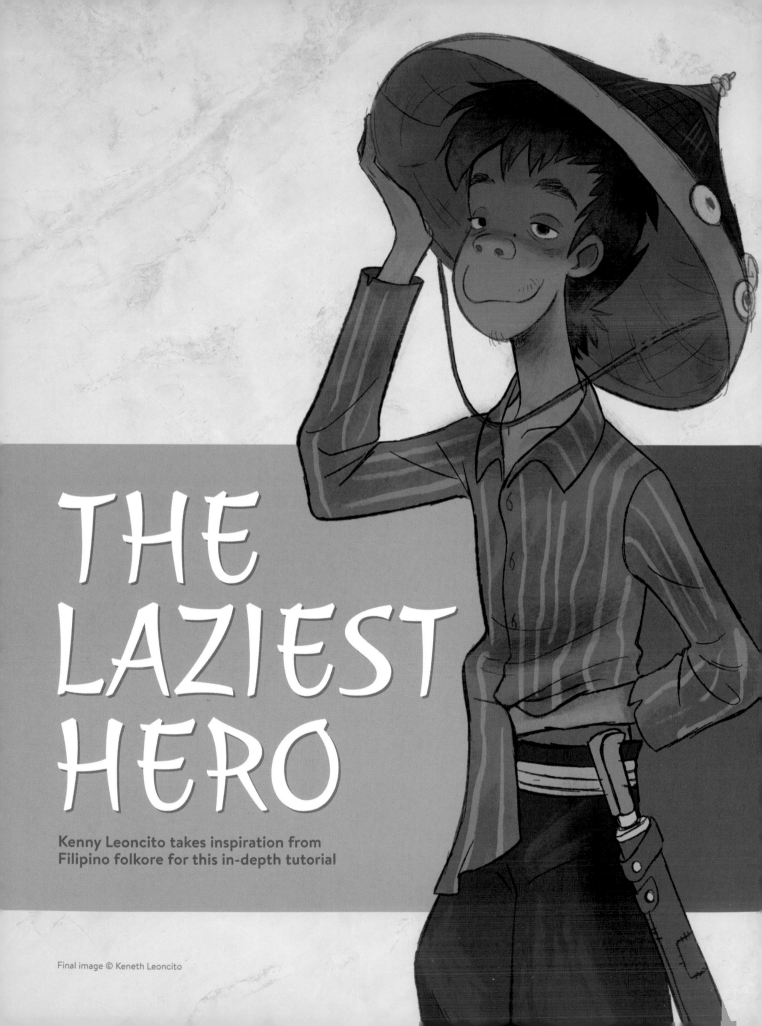

THE LAZIEST HERO

Kenny Leoncito takes inspiration from
Filipino folkore for this in-depth tutorial

Final image © Keneth Leoncito

DRAWN FROM MEMORY

I grew up hearing plenty of folk tales from my parents and family members, which lived in my brain as floating concepts without pictures. Being able to design characters as an adult has been a great way for me to return to those stories and think about their heroes and villains in new and thoughtful ways. For this tutorial, I'm going to focus on Juan Tamad, one of the characters from these tales. His name roughly translates as 'Lazy John'. I'll be using primarily Procreate and Photoshop, but you can use any digital tool to follow along.

RESEARCHING THE CHARACTER

I start by looking at various books to research my subject matter, including *Philippine Folk Literature: An Anthology* and *Philippine Folk Literature: The Myths* by Damiana L. Eugenio, and *Filipino Children's Favourite Stories* by Liana Romulo. At the start of the design process, it's important to familiarize yourself with the source material you are working with. Doing so will help create an informed understanding and a sense of authenticity and respect towards the character you are designing, especially if you are drawing from another culture.

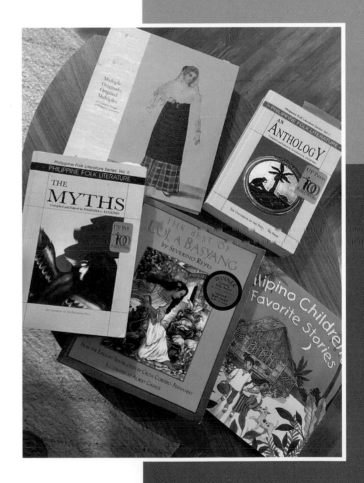

Even though this step can seem a little long-winded, I never skip reading about the characters I am working on. I'm looking for topics that relate to their lore to find inspiration for how I will reimagine them.

WHO IS JUAN TAMAD?

Juan Tamad is a figure in Filipino folklore known for his extreme laziness ('tamad' means lazy in Tagalog). He is often framed in comedic vignettes, pushing his relaxed attitude to the point of absurdity, to teach children the consequences of laziness. The story I grew up hearing the most goes as follows:

Once upon a time, a young boy named Juan Tamad came upon a guava tree with a large, shiny fruit hanging from a low branch. Too lazy to climb up the tree to fetch the fruit, Juan 'cleverly' decided he would save his energy and wait below the tree until the fruit fell on its own. So, with his mouth agape, Juan laid down beneath the tree and waited. As the hours passed, Juan fell asleep, but awoke to the smell of sweet fruit juice dripping onto his face. While he was asleep, a bat had grabbed the low-hanging fruit, and so Juan went home, full of nothing but regret.

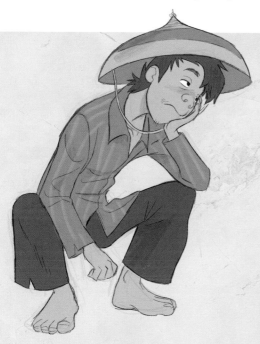

THE PRIORITY LIST

After taking some notes about the character I am working with, I make a list to jot down the key things I know about them. On this list, I write character traits and ideas of what they may look like. Having a clear list of qualities written out before I start drawing is a great way to keep focused on who the character is and what is important about them.

Right: I scribble down a list of qualities about Juan Tamad that are important to his character

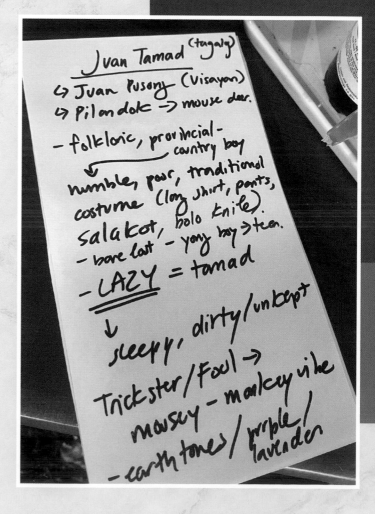

MAKING A MOOD BOARD

I like to gather as many visual references as possible to serve as inspiration towards the design. I try to curate these visual references to help me get more specific in the designing process. For this character, I focus on gathering folkloric images and illustrations related to Juan Tamad – references for his hair, face, and body type, and textile and costume examples. I also consider any contemporary pictures of characters who look how I imagine Juan Tamad to look.

You don't need to make the reference board too elaborate. Sometimes a simple folder with a pile of images can be enough, but organizing your references into related groups will prove more useful as you continue with the design process.

A PLAN COMES TOGETHER

Once I've set out to create a character, I think about every step I'll need to take to get my final design. Personally, I'm pretty task-oriented, so I like to make a game plan of actionable items. This way, I can visually imagine how much work I will need to get through and approximately how long it might take to get it all done.

For this project I aim to explore faces, body types, and costume silhouettes, then reduce my ideas to a more narrowed-down 'final' design, a few expressions, and poses. I make a series of thumbnails to keep track of what I need to do.

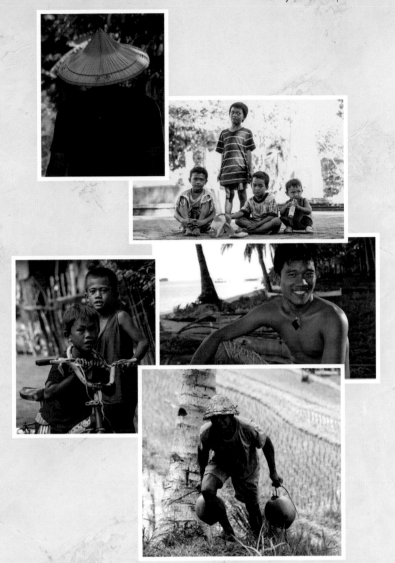

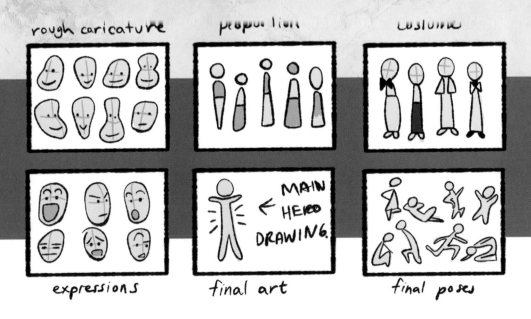

Above: A small sample of the images I gathered as references

Left: I quickly rough out my design 'battle plan' on 4:3 thumbnails

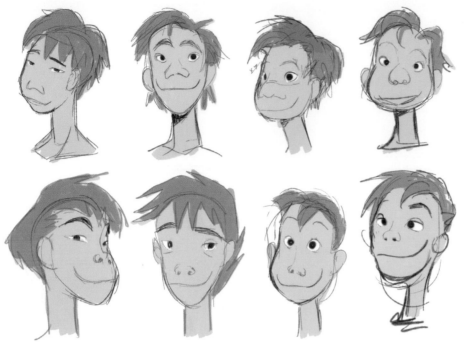

'I'M FOCUSING ON EXPLORING AND PUTTING THOUGHTS DOWN AS I DRAW, WITH THE HOPE THAT I MIGHT DISCOVER SOMETHING COOL'

ROUGH BEGINNINGS

When developing a new character, I start by focusing on the face. I look at references of people that would seem like a good fit and try to simplify and draw out their unique qualities. This stage is all about experimenting, so it's okay for the artwork to not look great. I'm focusing on exploring and putting thoughts down as I draw, with the hope that I might discover something cool. At the same time, I start to thumbnail some potential body proportions. For this character, I imagine him being a lanky or skinny teen.

Above & right: I explore different faces and a wide variety of proportions. The drawings are very loose, but I'm just experimenting at this stage

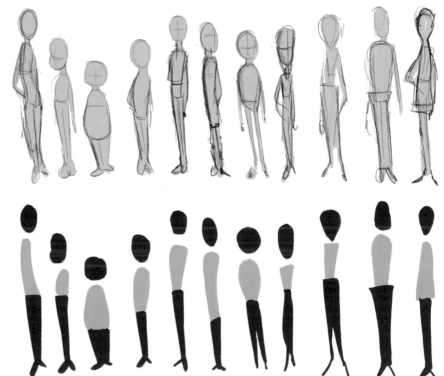

THE RULE OF CONTRAST

I always keep the rule of contrast in mind as I design. This rule tells me to design in shapes and volumes that are big (70%), medium (20%), and small (10%). The idea is that the eye will be drawn to areas that are different from one another, allowing you to create designs that are dynamic, varied, and interesting. Throughout the tutorial, you will see me divide the drawings into different coloured segments, which is just me looking and seeing if my design has enough variety of big, medium, and small shapes.

EXPLORING COSTUMES

I now take the faces and proportions I've come up with and try to narrow down the design. I make sure to look back to the notes I took earlier and focus on the elements I want to portray. In this pass I like to also explore the different silhouettes and costumes the character might wear. I deeply consider which parts of their costume feel essential to the character. The clothes and accessories placed on the character can reflect their background, personality, and tell a unique story on their own. I try to make sure I don't load the character up with too much stuff, drawing focus to one main element (such as a bigger shirt, longer pants, and so on) so the character remains easy to read.

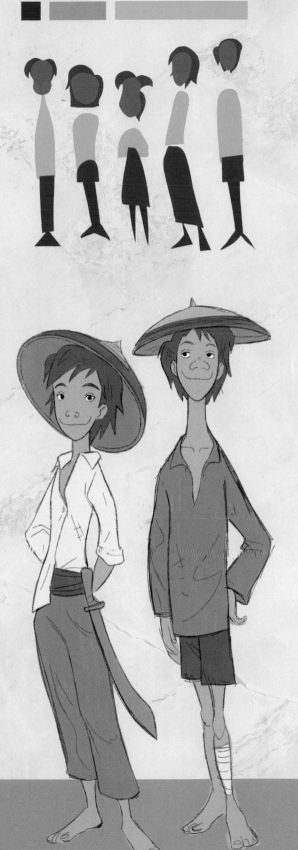

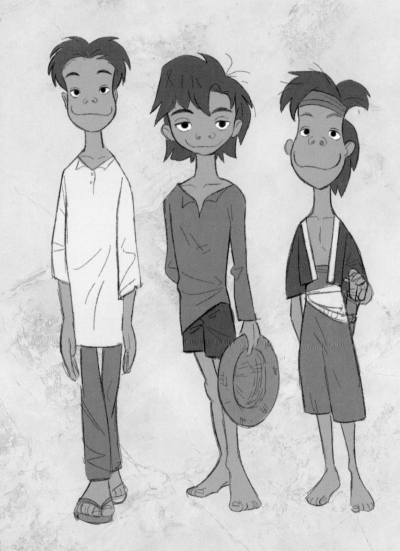

Above: I create five more designs and start to explore what the character could be wearing

REVISE AND REVISE SOME MORE

At this point, I take a look at my most recent designs and make some decisions about which elements to take forward. If you're working as part of a team, taking notes and making revisions based on the opinions of your peers and leadership is an essential part of creating the most useful and appealing design possible.

I make note of the specific things I'm enjoying and start to put things together, pushing the design to really nail the 'lazy' and 'sleepy' qualities of Juan Tamad, while also increasing the design's level of appeal.

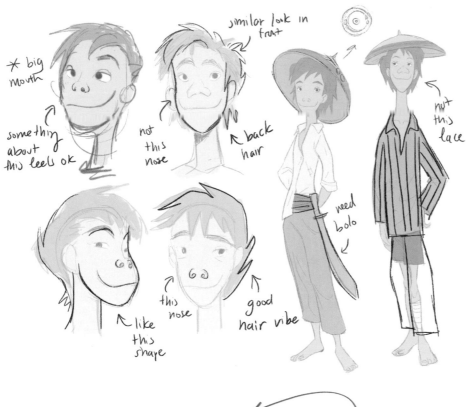

'I TAKE A LOOK AT MY MOST RECENT DESIGNS AND MAKE SOME DECISIONS ABOUT WHICH ELEMENTS TO TAKE FORWARD'

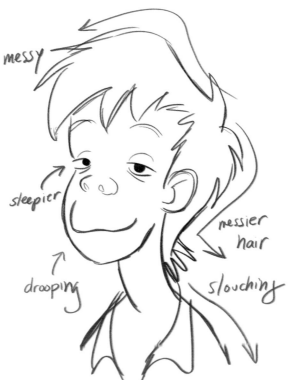

Above: I select the drawings that are working out the best, identify which elements look good and begin to put things together

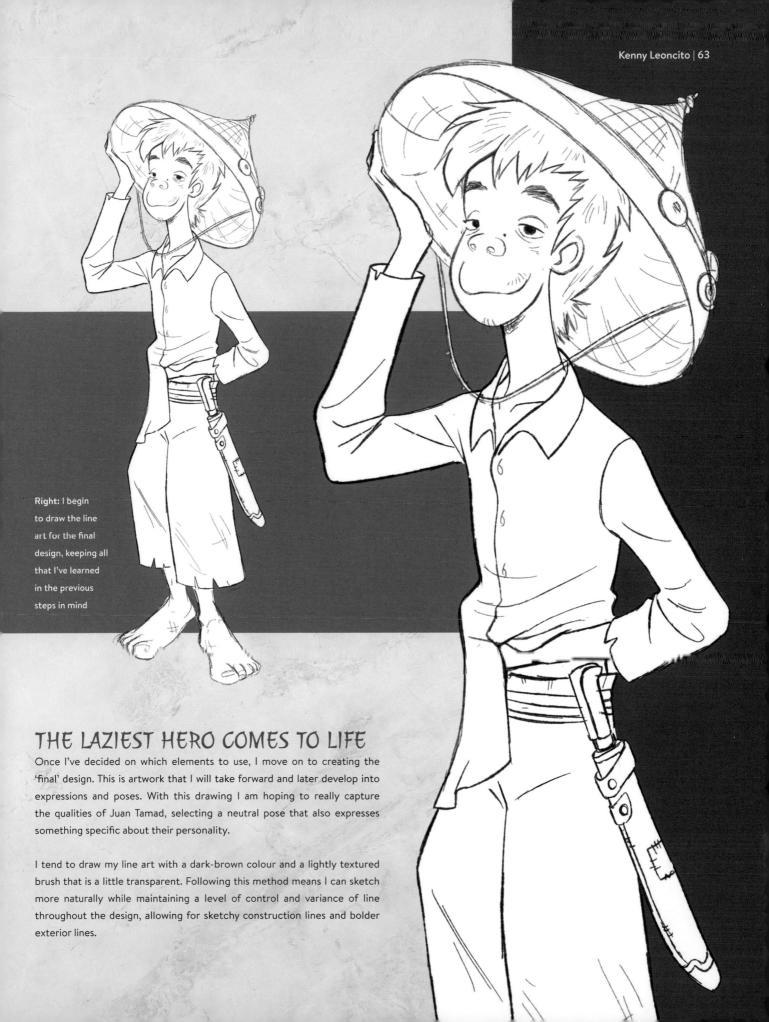

Right: I begin
to draw the line
art for the final
design, keeping all
that I've learned
in the previous
steps in mind

THE LAZIEST HERO COMES TO LIFE

Once I've decided on which elements to use, I move on to creating the 'final' design. This is artwork that I will take forward and later develop into expressions and poses. With this drawing I am hoping to really capture the qualities of Juan Tamad, selecting a neutral pose that also expresses something specific about their personality.

I tend to draw my line art with a dark-brown colour and a lightly textured brush that is a little transparent. Following this method means I can sketch more naturally while maintaining a level of control and variance of line throughout the design, allowing for sketchy construction lines and bolder exterior lines.

LOOSEY-GOOSEY

Even though at this point I'm drawing something more final, I honestly don't aim to make anything too clean. You can draw roughly, loosely, and more naturally, and still show clarity and intent in your drawings. A clear but loose drawing can have a lot of value compared to something clean but stiff. Of course, the level of tightness you need in your drawing will also depend on the type of project you're working on!

'CONTRASTING THE RELAXING COLOUR OF PURPLE WITH NATURAL, MUDDY, EARTHY TONES'

BASE COLOURS

After we are satisfied with our final lines, it's time to move on to toning and eventually colouring our final design. Before jumping to colour, I start with black-and-white values to ensure I have a nice variation of tone throughout the whole of the character. For Juan, I think using purple and brown will be fun, contrasting the relaxing colour of purple with natural, muddy, earthy tones. All throughout this process I'm still thinking about the rule of contrast, breaking up the main black/white and colour structure into distinct, clear, and varied colour groupings.

Right: Start off by shading your character in black-and-white values before moving on to colour

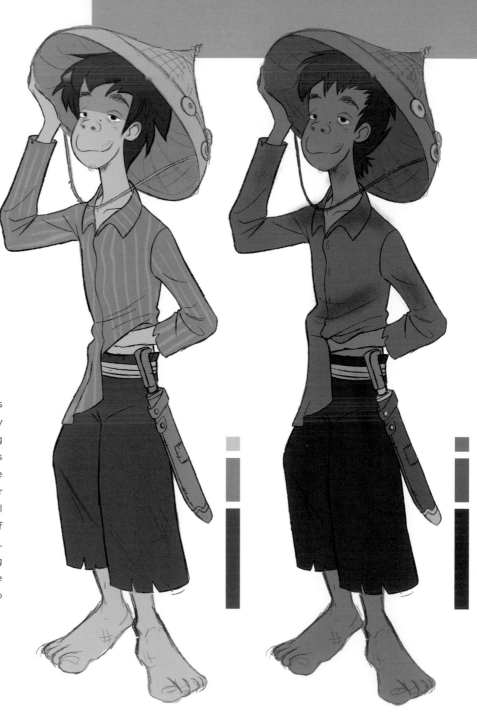

Left: I begin to roughly shade the skin with a warm, light grey tone

Below: Building on the core shadows with a darker, warmer tone

SOFT SHADOWS

As I move on to shading and rendering the final character design, I tend to paint roughly but with enough care to describe the main shadows affecting the character. I start by painting with a warm, light-grey tone on the skin. I set this tone to Multiply so that it acts like a soft shadow on the character. I transition the shade softly to a brighter and more saturated salmon colour, which creates a bounce-light kind of effect.

RENDERING THE FINAL DESIGN

I continue to render the character, still with a rough yet appealing approach. I build on the core shadows of the skin with a darker, warmer tone. I add a band of a saturated colour between the local colour of the skin and the shadows to create the look of subsurface scattering, which also helps in bringing out the vibrancy of the colours used. I also paint over the colours and the line art to build on detail and create more clarity. Keep going and before you know it, you'll be done!

SQUASH AND STRETCH

Now I have a final design, I move on to creating expressions and poses for the character. I find this sort of exercise more meaningful than drawing a full-character rotation, because expression and pose let you explore more about your character, injecting more personality and story.

I start by drawing a full-stretch face and a fully squashed, compressed face. This exercise is like a little warm-up and helps me to understand how the character's face works. Then by rotating the face left to right, up and down, I aim to explore a full range of facial movements, while also ensuring each expression is suited to Juan Tamad. I'm trying to capture smugness, distaste, and tiredness.

Right: An expressions sheet for Juan Tamad, showing a range of emotions

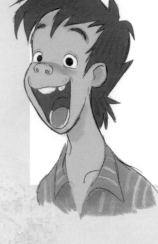
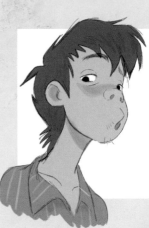
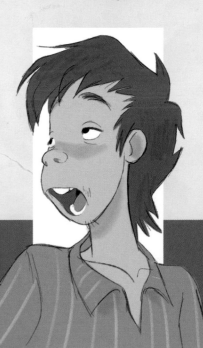
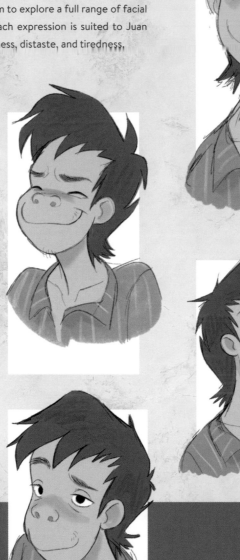

PUSHING POSES

After familiarizing myself with Juan's face, I move on to creating some full-body poses for the character. Typically, with any drawing I start off with an extremely rough gesture, just to get the idea of what I want to draw on the page. I then tighten it up with each pass, aiming to push the design little by little, gradually working towards something more specific.

TELLING A STORY

Drawing poses is a great way to explore more narrative for Juan Tamad. I try to choose a range of poses that tell a story or show off the character's personality, sometimes drawing them in a sequence of events: sleeping, waking up, stretching, and so on. I like to choose poses where the character is standing, sitting, laying down, or crouching, just so we can see the full range of motion, and how the fabric or anatomy looks in those positions.

Right: Developing poses – I start with a rough gesture and draw multiple rough passes, refining the image

Below: A pose sheet showing Juan Tamad engaged in various activities

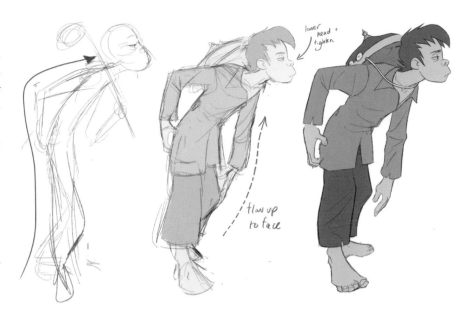

'I TRY TO CHOOSE A RANGE OF POSES THAT TELL A STORY OR SHOW OFF THE CHARACTER'S PERSONALITY'

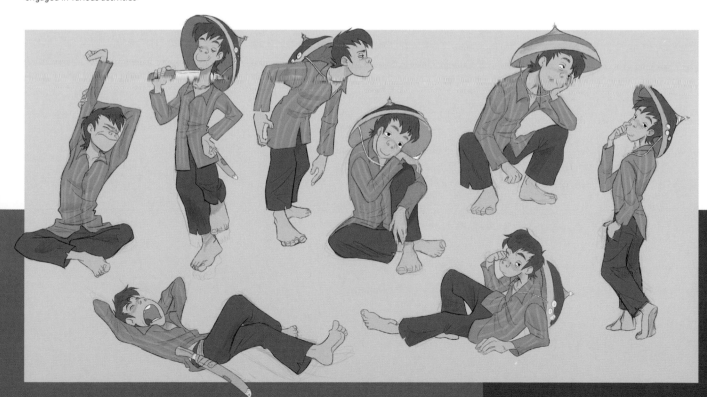

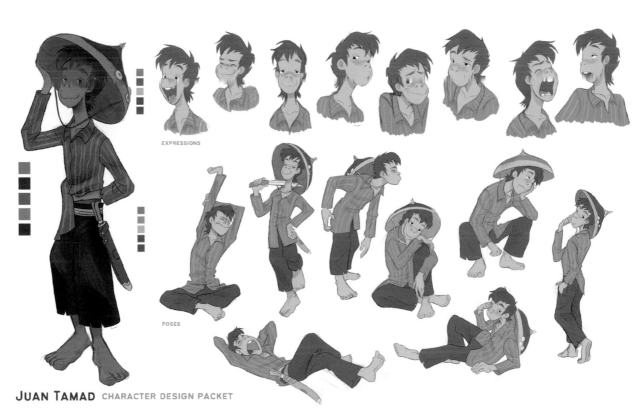

EXPRESSIONS

POSES

JUAN TAMAD CHARACTER DESIGN PACKET

The final design page for Juan Tamad

PACKETING THE PROJECT

For the last step, I like to take all the finalized elements and place them together on a single sheet. In case I need to return to the design later, or maybe have to send it off to another department if I'm working as part of a team, it's good to have the design labelled and packeted together in a presentable way. This is also a good idea if you are planning to use the character as part of your portfolio. My tip here is to think about how you organize your artwork, making sure each section is arranged sensibly, allowing your audience to easily look at the character. I use a large space for the main hero and smaller zones for expressions, poses, colour, and fabric callouts, and so on. If needed, you can make an additional page. You don't have to go too crazy for a step like this – the design should speak for itself.

And that's it, we're done! Thanks for following along with me and Juan – I'm wishing you all the best in your design endeavours! Salamat!

Design with
a ghost story
in mind

ARTIST CATCH-UP:

DOM MURPHY

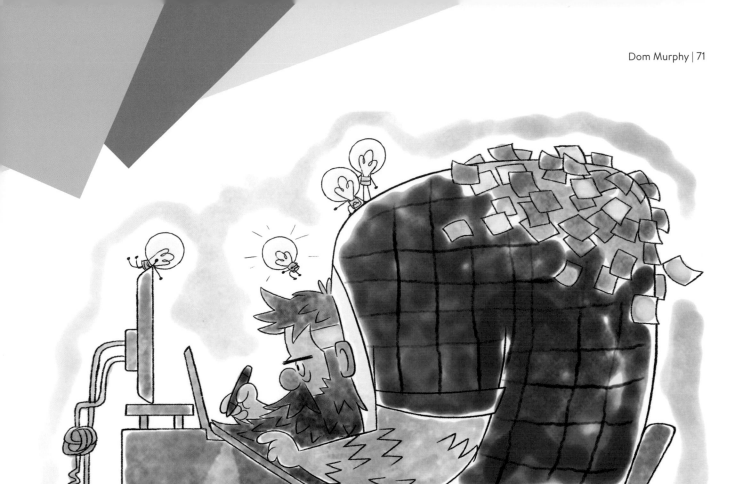

Self-portrait

Hi Dom, welcome back to *CDQ!* Can you start by letting our readers know about your career so far?

Hi *CDQ!* Thanks for having me back, it's always a fun time and a pleasure. I have been very fortunate and lucky in my career so far – I've been given some fantastic opportunities to work on amazing projects with great folks. My career in animation kicked off pretty late in the grand scheme of things, it wasn't until my late twenties that I got a solid footing in the industry after a decent amount of time and graft trying to break in. I guess this gives credence to the old saying that it's never, ever too late, and to hang in there. Since that opportunity arose, though, it's been a dream come true! I've had the pleasure of working on TV shows and feature films with some of the most talented and amazing folks in the industry, sometimes working alongside a lot of the artists I grew up admiring, which is always a mind-blowing experience. Being artists, I don't think that sense of childish wonder ever leaves us, so getting to experience these things first hand, that we never thought possible as kids, never loses its charm and is always a bit surreal. Sure, like any career it has its ups and downs, and some days can be tougher than others, but there's a spark of magic you would be hard pressed to find in any other walk of life.

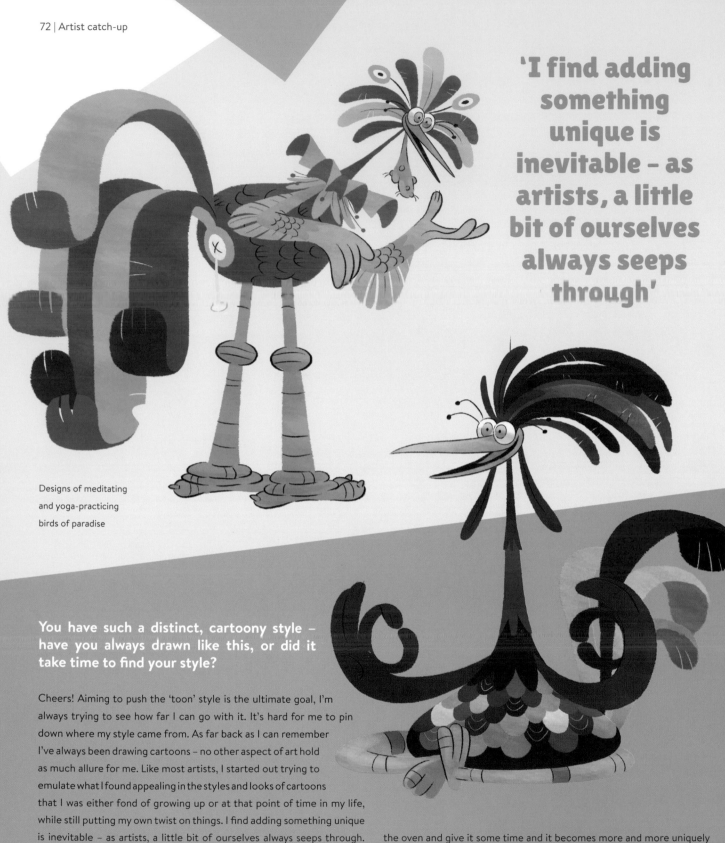

'I find adding something unique is inevitable – as artists, a little bit of ourselves always seeps through'

Designs of meditating and yoga-practicing birds of paradise

You have such a distinct, cartoony style – have you always drawn like this, or did it take time to find your style?

Cheers! Aiming to push the 'toon' style is the ultimate goal, I'm always trying to see how far I can go with it. It's hard for me to pin down where my style came from. As far back as I can remember I've always been drawing cartoons – no other aspect of art hold as much allure for me. Like most artists, I started out trying to emulate what I found appealing in the styles and looks of cartoons that I was either fond of growing up or at that point of time in my life, while still putting my own twist on things. I find adding something unique is inevitable – as artists, a little bit of ourselves always seeps through. Grasping onto that little bit that's you is key, in my opinion. Recognizing what it is and why you made those decisions, and then isolating and refining them leads to some happy accidents, and suddenly you have the beginnings of what could be considered a personal style. Stick that in the oven and give it some time and it becomes more and more uniquely yours. Of course, as the years go by, our tastes and influences change, projects leave lasting impressions, and this all affects our art, forever growing and changing. I like to think art styles are a constant work in progress.

Trying to find designs for a team of Baseball Bats

Who have been the biggest influences on your art style?

Oh wow, how long have you got? There are so many influences on my work, not just in the field of animation, but video games, literature, illustration, and live-action movies. I was a 90s kid, and as a result I got exposed to that perfect blend of nostalgia for the 80s from older siblings, and then the kooky-ness that the 90s brought, with a sprinkling of anime in between. In animation, I grew up on the classic Saturday morning and after-school shows of Cartoon Network, The Disney Channel, and Nickelodeon. The work of Genndy Tartakovsky and Craig McCracken filled my childhood with

Late for bingo night – she had her hair freshly blue rinsed, too

so many memorable shows that left a lasting impression, as did Peter Lord and Nick Park, of Aardman Animations and *Wallace and Gromit* fame. Some of my earliest cartoon memories are that of Don Bluth's feature work. To this day, I still get misty-eyed over *The Land Before Time*. And of course, there's the great Hayao Miyazaki and Studio Ghibli that strike a chord of wonder and whimsy in almost everyone.

Then there's video games – they are such a big part of my life that they can't help but influence my work. In literature and film, *The Lord of the Rings* books and films are a big influence, as are Tove Jansson and anything Moomin related. Oh, and Roald Dahl with Quentin Blake's beautiful illustrations. Finally, I have to say that every person I've had the pleasure of working with, past and present, has influenced my work greatly.

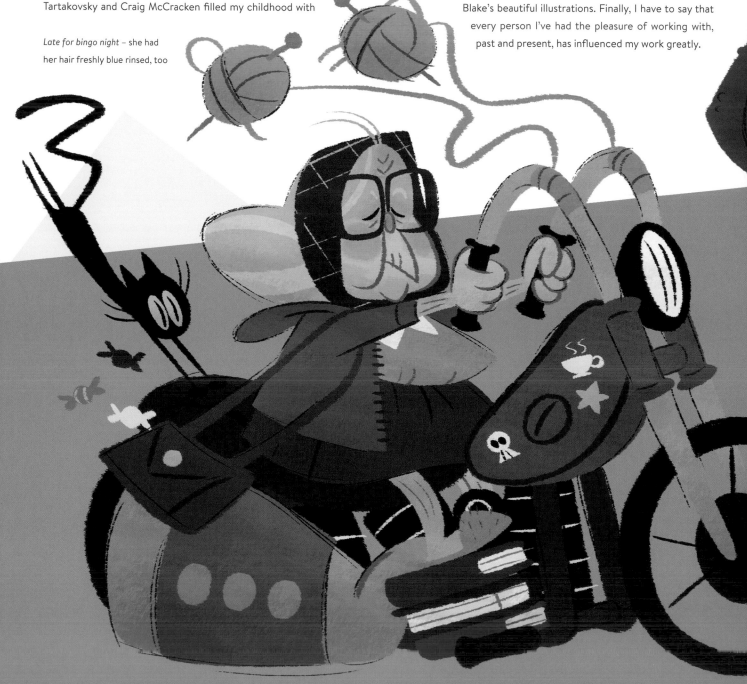

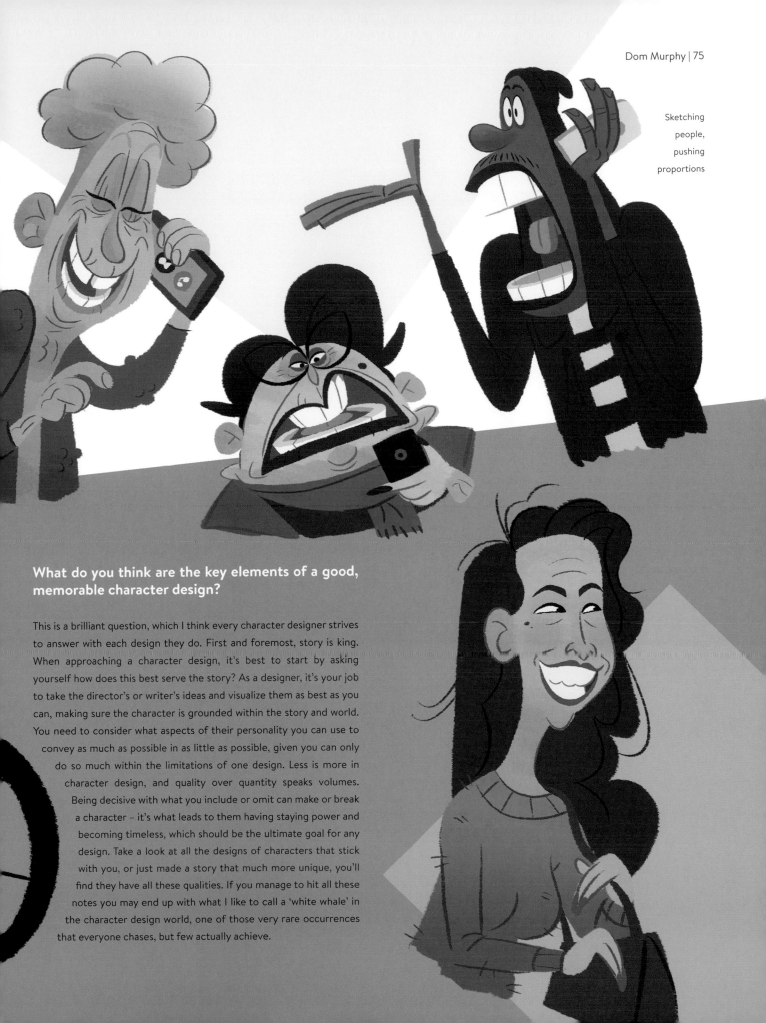

Sketching
people,
pushing
proportions

What do you think are the key elements of a good, memorable character design?

This is a brilliant question, which I think every character designer strives to answer with each design they do. First and foremost, story is king. When approaching a character design, it's best to start by asking yourself how does this best serve the story? As a designer, it's your job to take the director's or writer's ideas and visualize them as best as you can, making sure the character is grounded within the story and world. You need to consider what aspects of their personality you can use to convey as much as possible in as little as possible, given you can only do so much within the limitations of one design. Less is more in character design, and quality over quantity speaks volumes. Being decisive with what you include or omit can make or break a character – it's what leads to them having staying power and becoming timeless, which should be the ultimate goal for any design. Take a look at all the designs of characters that stick with you, or just made a story that much more unique, you'll find they have all these qualities. If you manage to hit all these notes you may end up with what I like to call a 'white whale' in the character design world, one of those very rare occurrences that everyone chases, but few actually achieve.

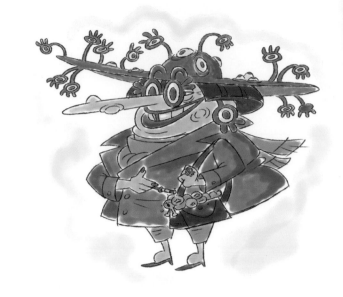

'Character design is so versatile a subject matter that it allows you to draw inspiration from practically anything'

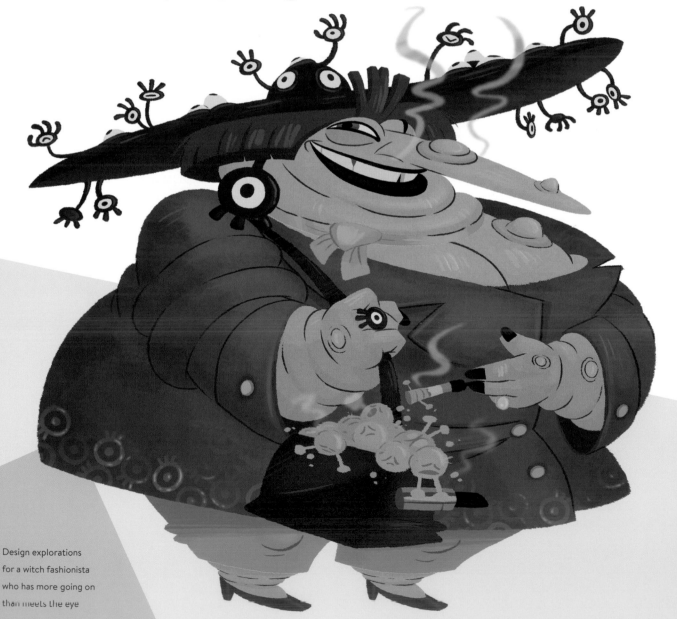

Design explorations for a witch fashionista who has more going on than meets the eye

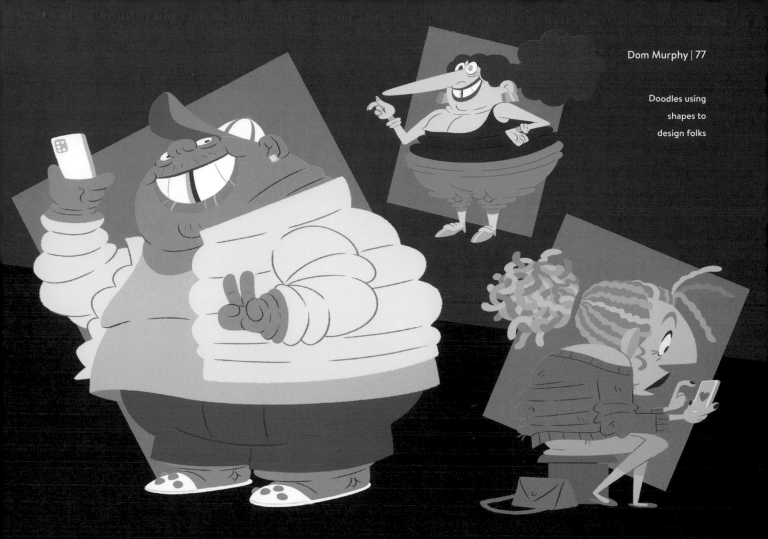

How important is thinking about shapes to you, and where in your character design process do they come into play?

I could sit here all day and discuss shape language! It's one of the best tools and techniques a designer has at their disposal, but I fear a lot of folks overcomplicate things or just feel too intimidated by it, which shouldn't be the case at all. All you need is your eye and a strong understanding of what it is that you find appealing in a design, and why. Shapes can be your friend or your worst nightmare as you try to make them work. You can be strict and abide by the rules of the shape or you can just use it as a guideline or underlying structure, not being tied down to it. I personally use the latter method, as I find it more fun and natural. I also like to take everyday objects, man-made or natural, and use their shape combinations for inspiration. For example, this can really help with creating head shapes. For the most part, 'how to' books (or even teachers) will tell you there is only one way to draw a head, with a ball and jaw combo. There's nothing wrong with that, but it can be good to experiment further, even if you're creating 'realistic' designs. Look at people's head and body shapes around you in real life – none are the same, but if you stick to one way of drawing them you'll struggle to convey this diversity. So, mix it up with different shapes and don't be afraid to push proportions. There is no right or wrong way – experimentation is the key to variation.

Your Instagram feed always astounds us with just how much variety and creativity there is with the types of characters you create, despite still being identifiably by you. Where do you find inspiration for your diverse characters?

I share so much! I like to use my Instagram as a personal doodle and design diary, giving folks a behind the scenes look in to how I think and my approach to designing characters. I can find inspiration for these characters everywhere and anywhere. Character design is so versatile a subject matter that it allows you to draw inspiration from practically anything, be that visually, from words on a page, or even music – there's no limit to it! As creatives, we craft some of the most imaginative scenarios and colourful worlds in our minds, filling those worlds with equally as colourful characters is the joy of character design. One of my favourite things when looking for inspiration for character design is people watching. I grab a notebook and doodle folks passing by, or people I know: friends, family, and co-workers. You can find so many interesting people out there. Their style, personality, and mannerisms can even spark inspiration that you can apply to non-human characters, giving them that much more variety and creativity and making them truly stand out.

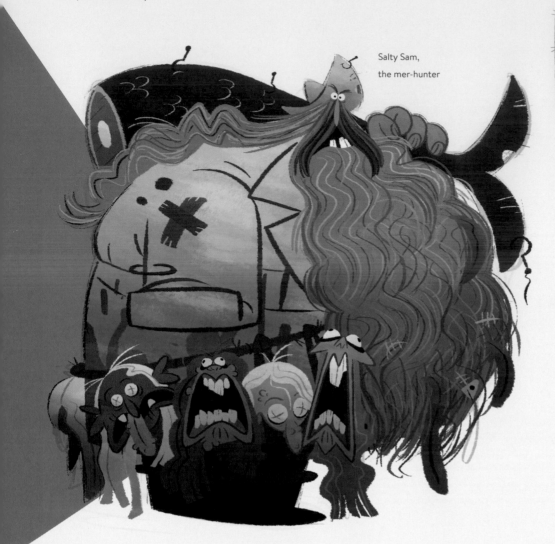

Salty Sam,
the mer-hunter

Blacksmith

You've worked with plenty of big studios – do you have any advice for getting noticed and finding work on big projects?

I owe a lot to folks from these studios discovering my work online and reaching out and taking a chance on me. I can't stress enough how beneficial social media can be for you and your work being discovered. It's why I always recommend keeping somewhat of a presence online, no matter how small, even if it's just posting your doodles every now and again. You never know who is watching or who it might end up in front of. Posting what you are passionate about and enjoy drawing is always a good shout, it shows through in your work and is plain to see. Furthermore, original and unique ideas are the bread and butter of character design. However, don't be afraid to have a crack at fan art of established characters and properties you enjoy every now and again, too. Some of my biggest opportunities came from directors or producers reaching out after seeing my takes on existing characters.

What has been your favourite project to work on?

Oh, now that's a tough one! I've honestly enjoyed every project I've worked on immensely. I'm a big believer that every project is a masterclass in the business of animation and should be treated as such. There's something to be learned and taken away from each and every one. A project that holds a particularly special place in my heart is my work on *Ruby Gillman, Teenage Kraken* with the fantastic folks at Dreamworks. Being my first foray into the world of feature films, I learned so much from the amazing crew and team. It was definitely one of those instances where I came away from the project wiser and a better artist thanks to the experience. I'd also single out my current project, *Doodle Girl*, with the amazing folks at Studio Meala, here in Ireland. It's one of the first projects where my role consists of more responsibilities in the design and visual process. I'm doing a bit of everything and enjoying every aspect of it. This is partly down to the nature of the project being fun and unique, but mostly down to the studio and every department being a joy to work with.

'I can't stress enough how beneficial social media can be for you and your work being discovered'

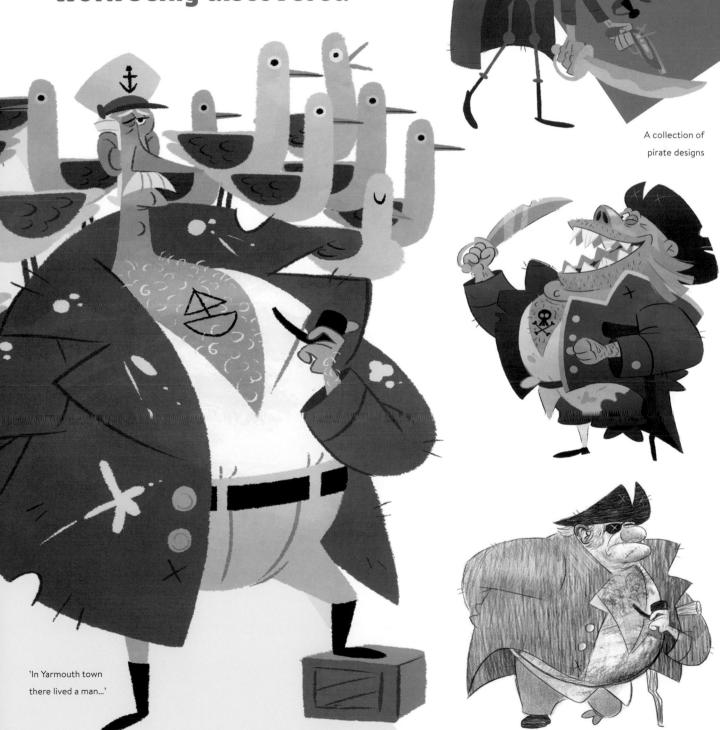

A collection of pirate designs

'In Yarmouth town there lived a man...'

'If I keep getting to have a hand in making fun cartoons that would suit me just fine!'

A.

8 LEGS
OR
4 ?

LE NEIGH!

C.

B.

SEAL BOUNCES!

MANE + TAIL TRIMMED

E.

D.

HORSE RADISH

F.

SIR SCALLIONS GUIDE TO CHIVE-ALRY!

(SPEAKS IN A TERRIBLE FRENCH ACCENT)

EN GOURDE!

SACRÉ BLEU! I HAVE BEEN LE OWNYAWN RINGED!

TAKES "DIRT NAP" TO HEAL!

* SNORE! * OUI! OUI! OUI! OUI!

Rough, early designs
for my *Sir Scallion* short

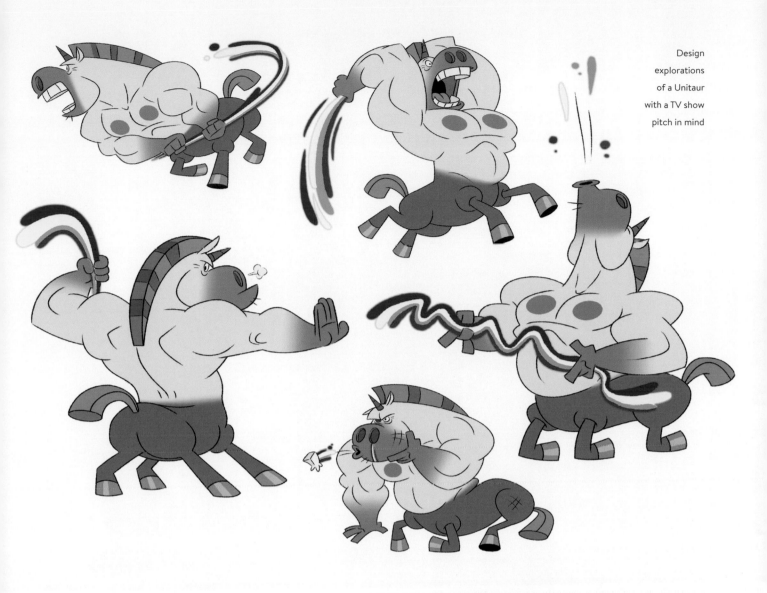

Design
explorations
of a Unitaur
with a TV show
pitch in mind

And Is there a dream project for you?

Honestly, if I keep getting to have a hand in making fun cartoons that would suit me just fine! If I had to choose though, definitely anything Tolkien-related in animation form. There's a certain appeal to the world and stories of Middle-earth that would lend themselves beautifully to animation. I wouldn't say no to a superhero related project or two and I'd also love a crack at some of Roald Dahl's stories. But mainly I'd love nothing more than to have opportunities to help bring more unique and original stories to life, be that through the concepts of others or the ideas of my own I have bouncing around.

Thanks for chatting to us, Dom! Are there any upcoming projects or anything else coming from you we should look out for?

Cheers *CDQ*, thanks for having me! There's a few projects in the works and to be announced that I had the fantastic opportunity to be a part of. As I previously mentioned, keep an eye out for *Doodle Girl* from Studio Meala. It's a project that's really pushing the genre of kid's TV shows to new heights, with unique takes and approaches, and a brilliant team attached. I'm excited for folks to see the finished product. I also have a few shorts in the works that are super fun. One is *Sir Scallion*, a story about the trials and tribulations of a little green onion knight, and his trusty steed Horseradish, as he tries – albeit very poorly at times – to revive the ways of chive-alry throughout the Kingdom and lands of Marrowmere. It's a punny one that's sure to tickle the fancy of any lovers of high-fantasy medieval veggie adventurers out there!

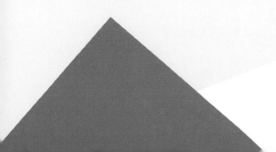

DEVELOPMENT GALLERY TWO
ANNELIESE MAK

I have always loved creating fantastical creatures and they make up the main body of my personal work. I usually have a rough idea of what I want to draw before I go in. Like many artists, I find that my best work happens when I take a few minutes before sketching to visualize what the final design might look like. Nevertheless, in the sketch stage (and even beyond) I do a lot of erasing, redrawing, scaling, and manipulation of elements. A digital medium is great for that kind of quick iteration and exploration. I always aim for readable silhouettes and fun, appealing shapes – whether it's in rendered pieces like these, or in the flatter, more graphic style that I also enjoy working in.

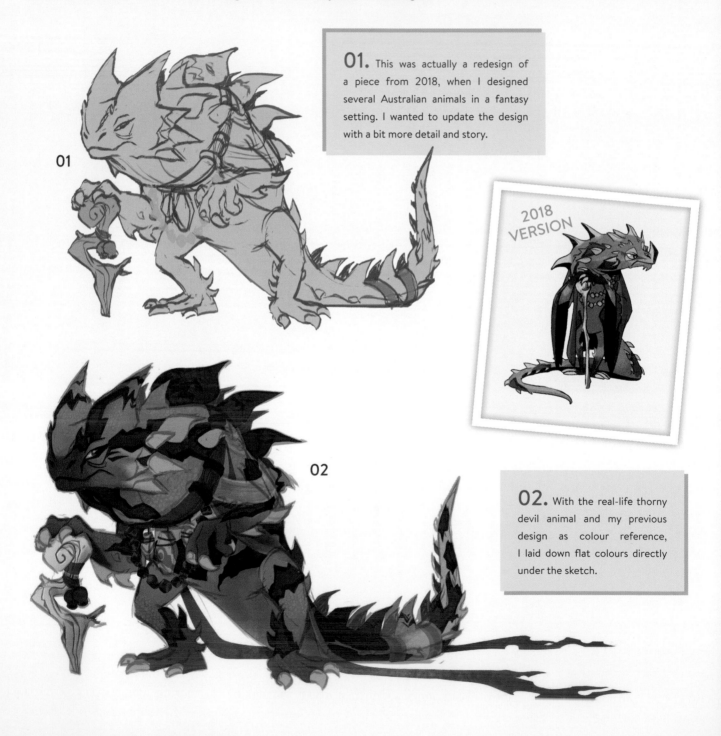

01

01. This was actually a redesign of a piece from 2018, when I designed several Australian animals in a fantasy setting. I wanted to update the design with a bit more detail and story.

2018 VERSION

02

02. With the real-life thorny devil animal and my previous design as colour reference, I laid down flat colours directly under the sketch.

03

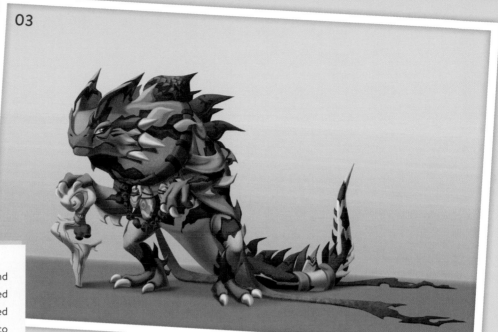

03. Next, I added light and shadows and the piece started to come together. I also added a very simple background to add some context for myself.

04. The most fun part of the process for me is adding texture, little dings on the horns, extra spike details – anything that I think will bring a bit more life to the character without detracting from the original design.

04

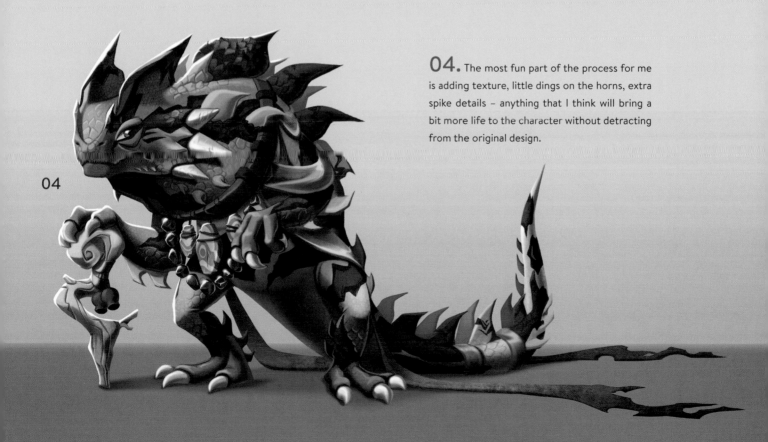

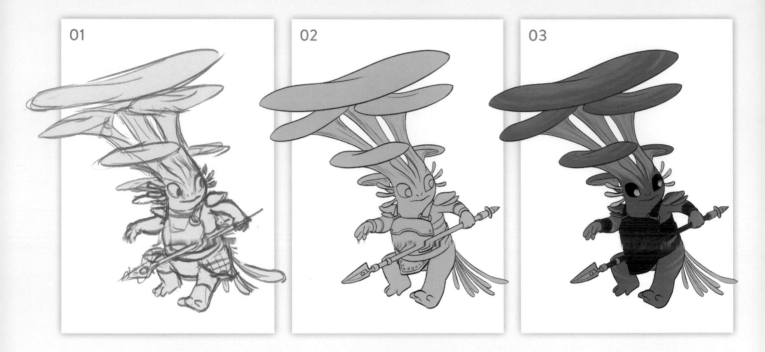

01. Following an autumn of mushroom foraging in Australia, I wanted to see what fun shapes I could use to create a mushroom warrior.

02. I wasn't 100% sure what kind of rendering style I would go for, but I went ahead and did some clean lines anyway, refining the shapes and details as I went.

03. Referencing a real-life mushroom for the base colours, I adjusted the other elements until the contrast and colour balance seemed just right.

04. This character has heavier lines than I would normally draw – it just felt right. I even went over the lines afterwards with a thicker, softer brush. Sometimes, it's fun to see what happens when you experiment!

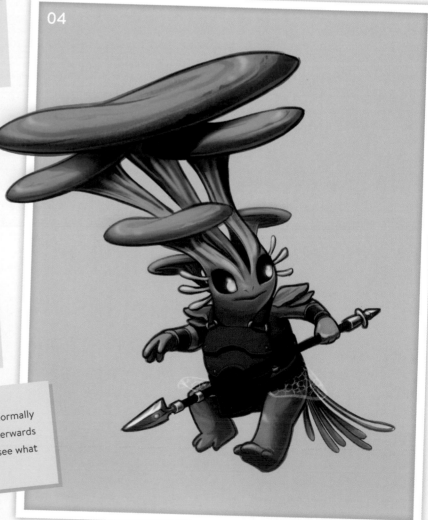

01

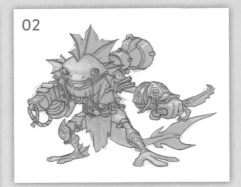

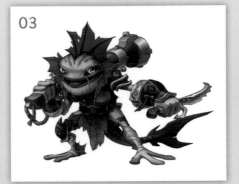

02

03

04

01. I knew I wanted to draw some sort of catfish-like creature, and I also wanted to practise drawing and rendering weapons and armour. All the little messy marks are remnants from iterating on the sketch.

02. Even though I knew I'd probably be painting over many of the lines in the end, I wanted to really tie down the specific details to make flat colours easier for myself. I revised the eyes to be rounder and more fish-like.

03. I had a fairly clear vision from the beginning, so it didn't take long to decide on a colour scheme.

04. Finally, I added textured scales and fins. Again, the painting and detailing is the most fun part of design for me – it can really bring a character to life and is incredibly rewarding.

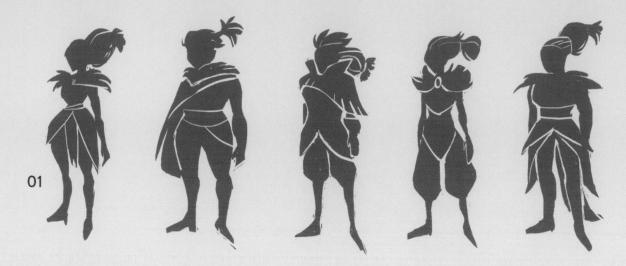

01

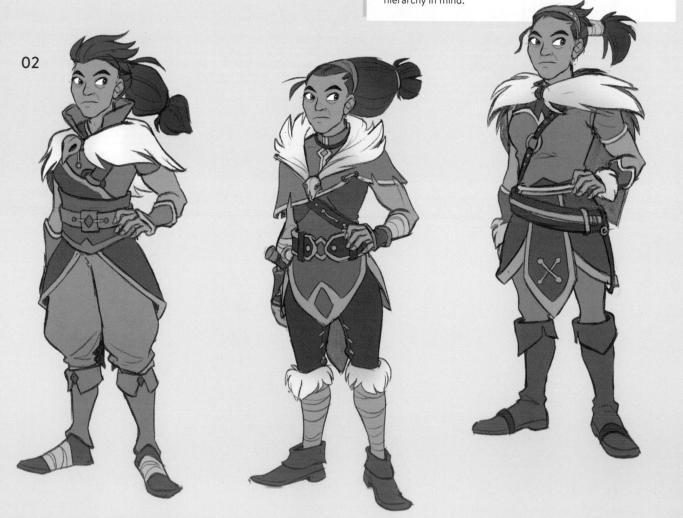

01. The goal here was to design the mother of an existing original character, and while I knew she was a free-spirited, hard-headed warrior, I had no idea of visuals. I started by creating some very rough silhouette sketches.

02. Riffing off other characters already designed in the universe, I iterated on some hair and clothing options, always trying to keep a clean and clear silhouette and shape hierarchy in mind.

02

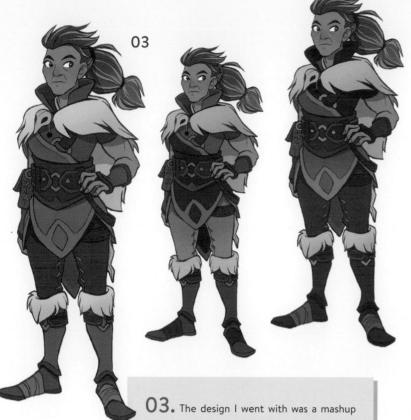

03

03. The design I went with was a mashup of the previous designs. Next, I explored some colour options, keeping in mind contrast and colour balance.

04. The final design – for now, at least! I'm always open to changing things and love revisiting older work to see how my design sense has changed. Maybe I'll do the same for this character in the future.

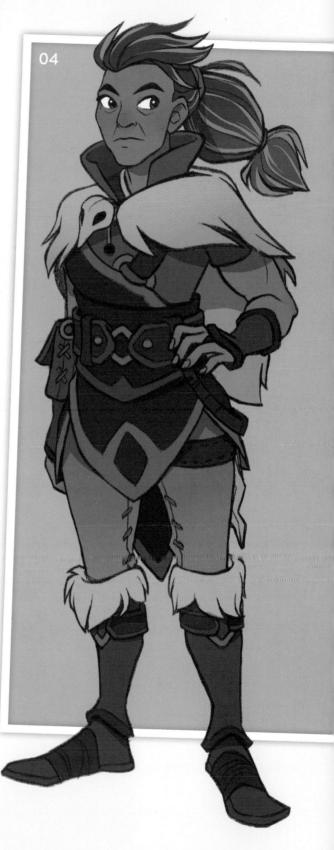

04

Colonial | Comical | Judge | 1700s?

Substance over style

When we first start out drawing, we tend to believe that our style is our most important asset. However, there are many instances where that is not the case, such as in character design! To create a memorable character, style is the least of your worries. Creating an emotional connection with your viewers and ensuring that they are intrigued by your character's backstory is essential. Let's look at some ways in which you can achieve this, creating a character from the prompt 'Magisterial mouse'.

Time travelling

Picking a time period generally helps you narrow down your focus and helps your viewers understand what they're looking at. I decide to focus on creating a colonial-era judge, simply because I love the outfits and wigs they wore in that age.

Thumbnailing and brainstorming

Once you have your references, start to thumbnail, thinking about character's key features, such as height, weight, personality, and their purpose or career. I decide to use a judge's gavel to show the 'magisterial' side of the brief, then start to thumbnail different versions of the design.

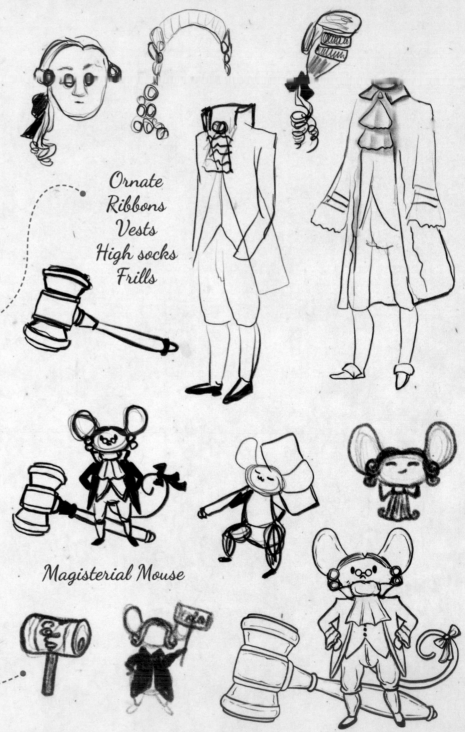

*Ornate
Ribbons
Vests
High socks
Frills*

Magisterial Mouse

A memorable mouse

The typical image of a judge is of a tall and imposing character – I want to subvert this cliché. Thus, our character is rather short and stocky, and I dress him in oversized clothes that make him look extra stuffy and rather comical.

Generic black robes

Vs

Concise unique design

It's hammer time

Hammer time

I take the gavel concept from my thumbnails and decide to make it massive! The 'Big Hammer of Justice' is the perfect humorous prop to add to my character – viewers are going to imagine how such an unimposing mouse is supposed to command order in the court with such a big hammer.

A helping of humour

Humour is always a great way to make a character memorable – my work often relies on some level of comedy. The oversized clothes of my character will also make for a great storytelling aspect as the viewer will start to question if this little mouse is truly fit for the job.

Final touches

For line art, I prefer pencil-like brushes to make my characters look like they belong in a story book. For colour, I chose to go with plain tones for the overall garb, except for the vest which is royal blue, and the jacket details which are gold. These elements help to emphasize the importance and prestige of the mouse's job.

Deliberate decisions

Make sure that all of your clothing and prop choices are deliberate and serve a purpose. These elements will lead the viewer to ask questions and the more questions about your character the better! This means you've done your job, and all the little details and props are helping your character come to life in the viewer's mind.

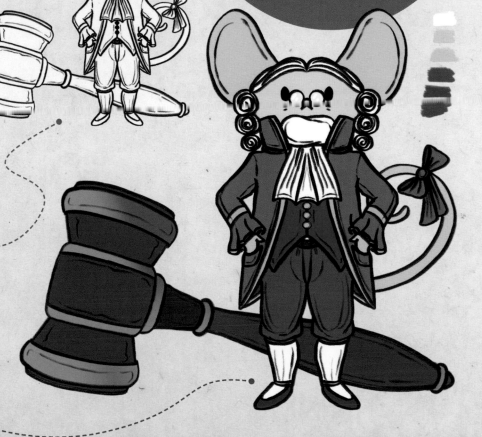

FEARLESS
FOXES

**Dan Sprogis imbues the environment with
character and brings a family of foxes to life**

Below: Writing down
your ideas is a great way
to get the ball rolling

BRAINSTORMING

→ Dangerous
→ Adventure

<u>Forest</u>	Rain	Mountain
Woods	Blizzard	Cliffs
<u>Swamp</u>	<u>Night</u>	Wind
<u>Dark</u>	<u>Creature</u>	Lightning
<u>Fog</u>	Scary	Fire
Storm	Death	

CHARACTER IS EVERYWHERE

The characters we create should live in a world they are born from, rather than be merely an avatar sitting upon a background. Coming up with worlds that fit your character and story can be tricky. Set yourself up for success by asking some questions: what is the story moment? Can our story take place anywhere, or does it have to be in a specific setting? If the answer is anywhere, what kind of location will best elicit the intended emotional response in the audience, and what can we do to strengthen that? In this tutorial, we will discuss how to create character through your environment, with thoughtful composition, colour, and shape language that support your story.

EVOKE EMOTIONAL RESPONSE

Tension	Mystery	Distress	Surprise
Fear	Danger	Unknowing	

BRAINSTORMING BEGINNINGS

With visual storytelling, we want to be sure that what we create is going to be the most impactful way of conveying a certain moment in the story. For this image, the prompt is 'A displaced father and son are on a dangerous adventure to find a new home'. I start by writing down ideas of places I think would be dangerous, gradually narrowing down to the setting I want to focus on: a dark and foreboding forest. Creating mood boards with reference photos and inspirational artwork can help spark your imagination.

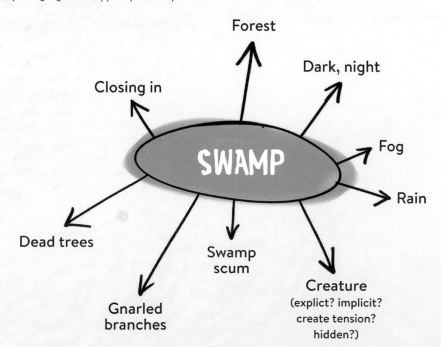

Forest

Dark, night

Closing in

Fog

SWAMP

Rain

Dead trees

Swamp scum

Creature
(explict? implicit?
create tension?
hidden?)

Gnarled branches

TAKING SHAPE

Start with simple, graphic shapes, with no more than three to five values, to divide up the frame. Refer to your warm-ups (see below) and think about how different tonal arrangements and compositions make you feel.

Try not to get stuck on a single thought, and if you do, draw through it until you begin to generate different ideas. Blank pages can be intimidating, so place your characters first so you can think of the different ways to lead the eye with shape. Thinking graphically rather than representational can be difficult at first, but doing so will lead to more unique and interesting compositions.

Below: Think about how to set the stage to most effectively convey the emotion you're looking for

 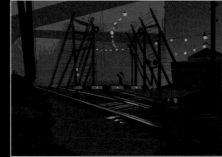

WARM UP

Creating quick composition studies of characters in environments from films with strong cinematography can be a great way to

warm up. Don't pay attention to the details, but rather the shapes that define the space and how they make you feel. Ask yourself: why do I like this? How does it make me feel? What are

the visual cues that reinforce these feelings? For this project, I warm up by studying a few scenes from Andrei Tarkovsky's *Stalker*.

SHAPES AS ARCHETYPES

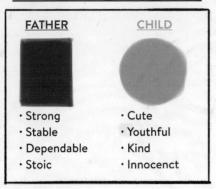

FATHER	CHILD
· Strong	· Cute
· Stable	· Youthful
· Dependable	· Kind
· Stoic	· Innocenct

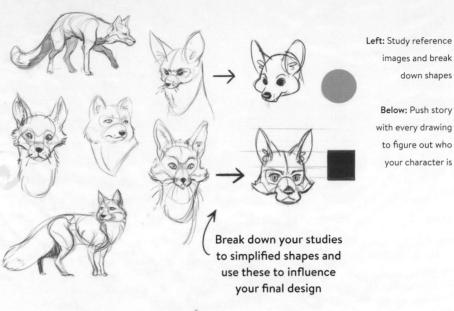

Left: Study reference images and break down shapes

Below: Push story with every drawing to figure out who your character is

Break down your studies to simplified shapes and use these to influence your final design

THINKING ANTHROPOMORPHICALLY

A classical approach to designing characters for animation is to use animals as avatars for human characters. When designing animal characters, there are two key things we need to do. First, we need to come up with archetypes for each character. Squares are often associated with strength, dependability, and stoicism, three traits I want my fox father to exude. Roundness is often associated with youth, so we can start there for our younger fox-cub character. Secondly, analyse the shape of your chosen animal and find ways to caricature and simplify their look so it becomes easier to draw, while still being instantly recognizable to your audience.

MEET JUNIOR

Let's focus on the son, Junior. He's smart, curious, new to the world, and possibly experiencing everything for the first time. Your first drawings will almost always be bad – and that's okay! You're trying to find shapes that work with your character's personality. The animal-shape analysis that we did earlier will help kick things off. Draw with ink, get your idea on the page, and then adjust with the next drawing, rather than erasing. Doing this allows you to draw quicker and not get hung up on one idea or small details. As a bonus, it will also increase your pencil mileage and you'll become a better designer and draftsman in the process.

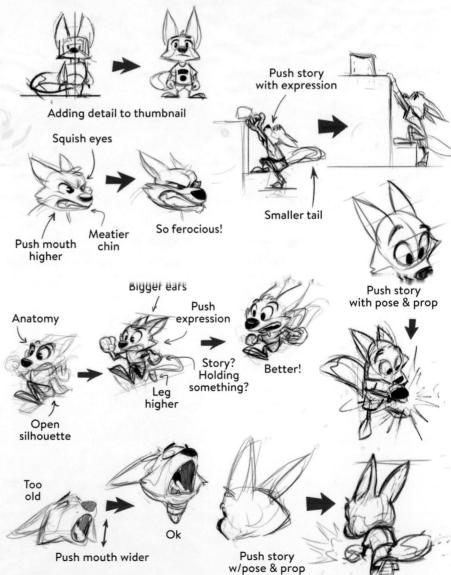

Adding detail to thumbnail

Squish eyes

Push mouth higher

Meatier chin

So ferocious!

Push story with expression

Smaller tail

Push story with pose & prop

Anatomy

Open silhouette

Bigger ears

Push expression

Leg higher

Story? Holding something?

Better!

Too old

Push mouth wider

Ok

Push story w/pose & prop

THE FOX FATHER

And now we can tackle the father – let's name him Bruce. A stoic, strong, and stout character, Bruce provides for his family by hunting. He'll probably have a rifle and maybe a hunting jacket, so let's start there. Doodling silhouettes in thumbnail size will let you get all your ideas down on the page quickly. Try out different poses to find a personality – something that feels right for your character. Next, start refining these sketches based on the thumbnails. If you're working digitally, you can increase the size of the thumbnails and work right over the top of them.

Below: Thumbnailing quick story ideas and poses will help get your creativity flowing

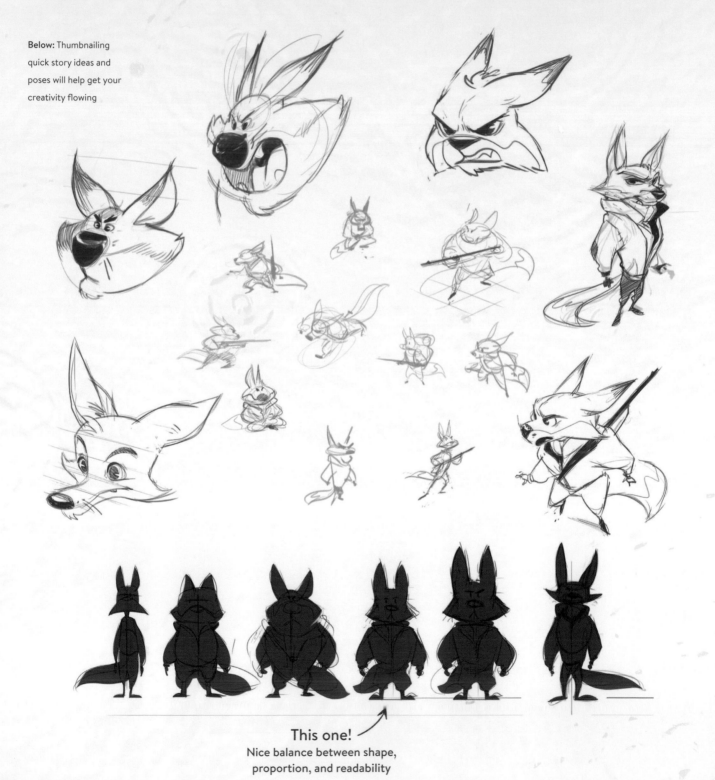

This one!
Nice balance between shape, proportion, and readability

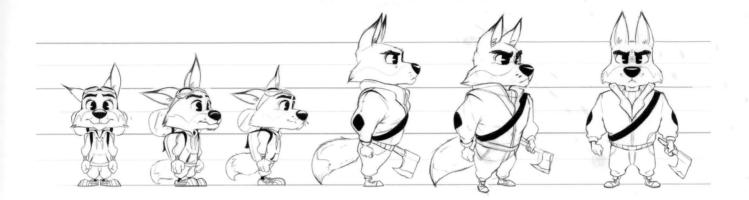

THE TURNAROUND

Next, we turn each character, drawing Bruce and Junior from different angles. In animation, turning your character is important so you can stay on style when drawing them in different poses. At this point, you're locking in your character's design. If you're working digitally and your software has a timeline and onion skinning (seeing several frames of a character at once), flipping the drawings back and forth can help keep consistency in volumes and forms. It's important that the character's elements stay on model from pose to pose, or else they can start looking unrecognizable. You can also add some colour here to define their costumes.

ENVIRONMENT AND EXPRESSIONS

Now is a good time to explore the emotions that your character feels when they're reacting to a situation. In our piece, the objective is to build tension for the audience. We know there is some unseen danger, so the goal is for the character's expressions to reflect that. The father, being a stoic guardian, will be on his toes and alert. I will contrast this passive pose with a more dramatic expression for the child. Maybe he's looking around frantically, suggesting he has heard something that he can't see? Or perhaps there's a foul smell in the air? You can communicate all these aspects of the environment by using the proper expression. Exploration is really the key word here. The more you do, the more possibilities you'll discover, opening the door to new and unexpected ideas.

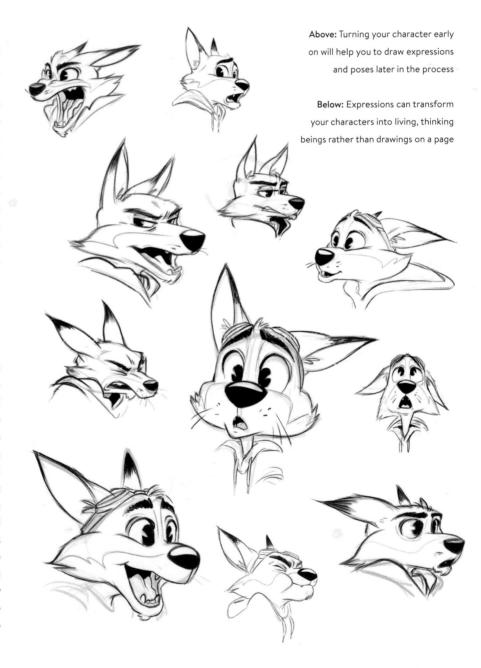

Above: Turning your character early on will help you to draw expressions and poses later in the process

Below: Expressions can transform your characters into living, thinking beings rather than drawings on a page

INTO THE SWAMP

Now that we have a few expressions we like, let's explore some of the possible poses we can use in our scene to connect to these expressions. I decide to set the action in a swamp, so the characters will be wading or swimming through water. Our characters are very different so they should each respond differently to the environment. Swamps tend to be shallow, so the father will be tall enough to wade through, but Junior would have to swim. Since they are on an adventure with survival gear and sleeping bags, let's have the kid ride atop his father's shoulders to keep both him and the equipment dry.

Below: Posing your characters is a chance to further develop their personalities

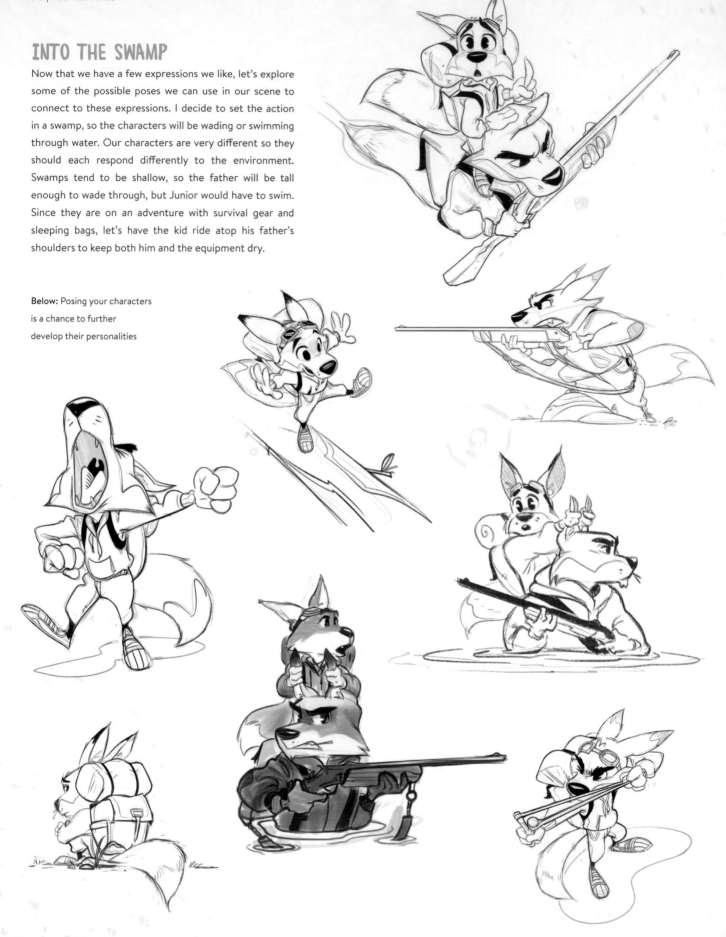

CHARACTERIZING YOUR ENVIRONMENT

Environment shapes can help push the mood of a scene, just like character shapes can help us recognize archetypes and put the audience in the mind-frame that we want. Starting with the trees, let's think how we can create a sense of danger for our characters and audience to feel. We often tend to associate old things as creepy, like that doll in your grandma's attic or the old Victorian house at the end of the street. Trees that have seen a lot of years start to twist and gnarl. Lichen can hang off the tree, pointing down towards our heroes as if the swamp is closing in on them.

FASCINATING FLORA

The reference for these trees are old oaks that I push to resemble old, gnarled hands, like a skeleton. I place them in a way that suggests hands reaching out to grab our heroes. The oaks have large bur-like growths with failed branches sticking out of them that are reminiscent of spikes or thorns. Moss and lichen hang off the branches to show that they have been here for a long, long time, and that light doesn't find its way down here very often, or easily. Leafy vines have crept up the surface of the trees and are almost suffocating them as they envelope the trunks.

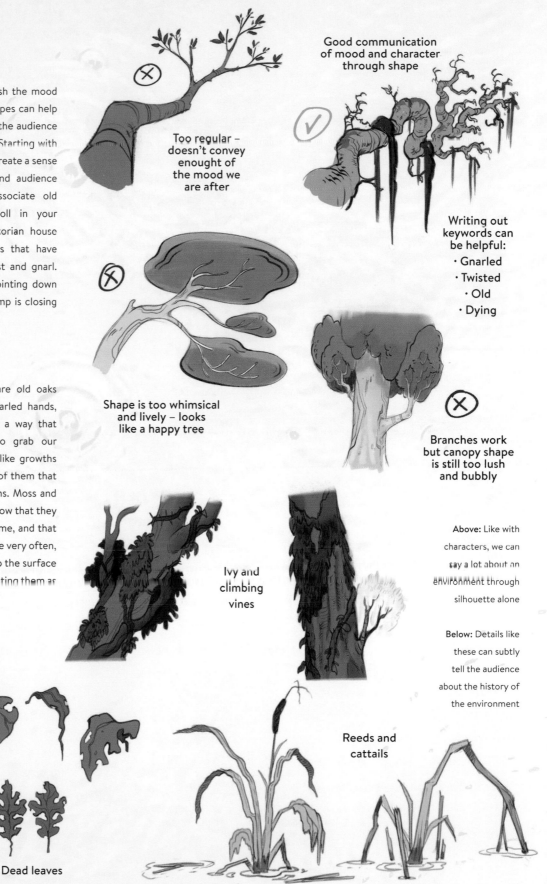

Too regular – doesn't convey enought of the mood we are after

Good communication of mood and character through shape

Writing out keywords can be helpful:
· Gnarled
· Twisted
· Old
· Dying

Shape is too whimsical and lively – looks like a happy tree

Branches work but canopy shape is still too lush and bubbly

Ivy and climbing vines

Above: Like with characters, we can say a lot about an environment through silhouette alone

Below: Details like these can subtly tell the audience about the history of the environment

Bur oak leaves

Healthy leaves Dead leaves

Reeds and cattails

ENVIRONMENT VERSUS CHARACTER

Another way to give your environment character is to almost pit it against your characters. The swamp water looks murky and we can't see what's beneath the surface. It's mucky, viscous, and its sludge and reeds are hard to wade through. Sticks and branches obscure parts of the forest and it feels as if everything is closing in around them. We see this in the image, but we also feel it – if we frame our characters properly, we can trigger an empathetic response of claustrophobia in our audience.

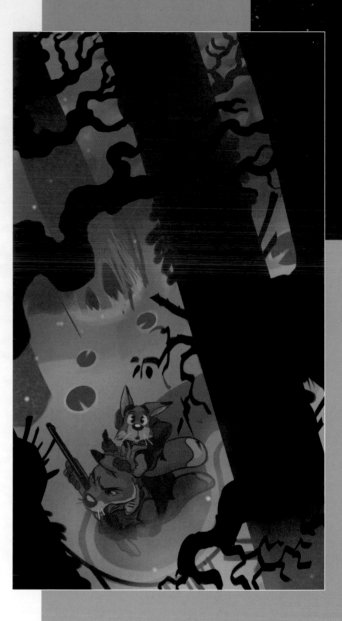

Reeds, cattails, and brambles create a physical impasse that can add to the psychological impact of your image

Moss/lichen

Rocks obscured by murky water

Reeds Moss/lichen

Pond scum

Murky water

Subtle reflections help indicate we are looking at water

Light cannot penetrate deep into water filled with sediment. The results are heavy subsurface scattering where light and shadow meet

Lilypads and reeds help communicate that the body of water is a swamp or pond

Left: Walking through a swamp is not only a physical obstacle, but a psychological one too

Right: We start to see our characters come to life with the addition of value

THE SCENE IS SET

Now that our composition, values, environment shape studies, character poses, and expressions are ready, it's time to tie everything together. Keep things relatively loose here and focus on creating a piece that communicates the mood and emotion it is intended to invoke. Because this is just a sketch, try not to become hyper-focused on detail in areas that aren't important. Our eyes only allow us to focus on one main thing at a time, our illustration should respect this. Put the most detail, contrast, and attention into the area where the audience should be looking. Eyes dart around an image so having one or two secondary focal points is good to have as well, but don't waste time putting detail everywhere.

GUIDED BY GRIDS

If you're struggling to get your character to feel like they belong in your scene, or maybe they feel a bit too floaty, using a simple grid will help plant them on a plane. This will ground them in your environment and help with perspective as well. Make sure that when drawing the grid, it matches the angle of the camera in relation to the ground plane. After establishing your plane, don't forget that their forms need to follow proper perspective too.

COLOURS EVOKE EMOTIONS

Colour plays a major role in communicating the emotion you are aiming for. Selecting colours is easily the most subjective stage of the design process, because it requires more intuition than anything else. Anyone can create a superficially beautiful image if all the other elements are in place, but it is your job as a visual storyteller to use colour to create meaning that strengthens the emotional impact. Gather some references and select some colour swatches that speak to you and that you feel fit your objective. For this example, the more natural green and yellow colours feel too friendly and inviting, while the reds feel too forced. Bluey greens feel just right, as they push the hazy, murky feel of the swamp.

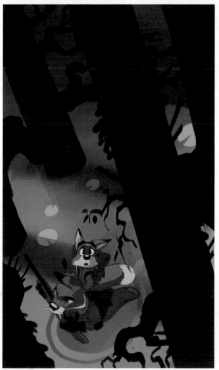

Above: Take your time – searching for the correct colours can be both fun and challenging

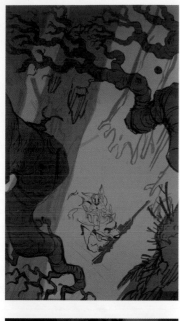

Left: You don't need detail everywhere. Be selective and create primary and secondary focal points

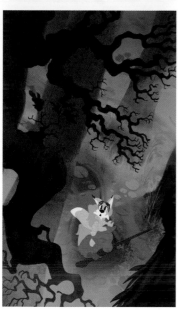

FOCUSING ON FOXES

Once the composition is locked in, you can begin painting. Keep things simple, referring to the preliminary work, to help tell a clear story and stay focused. Don't get bogged down in the details of elements that don't really matter. Do you really need to see highlights or reflections on every leaf or water ripple? Focus on what's important: your characters and what is going on in their heads. Every other element should be working to support your main goal. In this case, the reeds, brambles, and the thick swamp scum is physically difficult to get through. The fog obscures the light and the characters' vision. The trees, branches, and lichen are closing in around them to help convey a sense of claustrophobia.

QUICK ADJUSTMENTS

One trick in Adobe Photoshop that is often overlooked and underused is the Fade tool. I like to use this as a quick glaze or adjustment when I'm sketching and painting, so I can really nail down values and colour temperatures. After painting a stroke, hit Alt+Shift+F (Cmd+Shift+F for Mac) to adjust opacity quickly. This shortcut also works for a variety of additional commands, including image adjustments, strokes, fills, and filters.

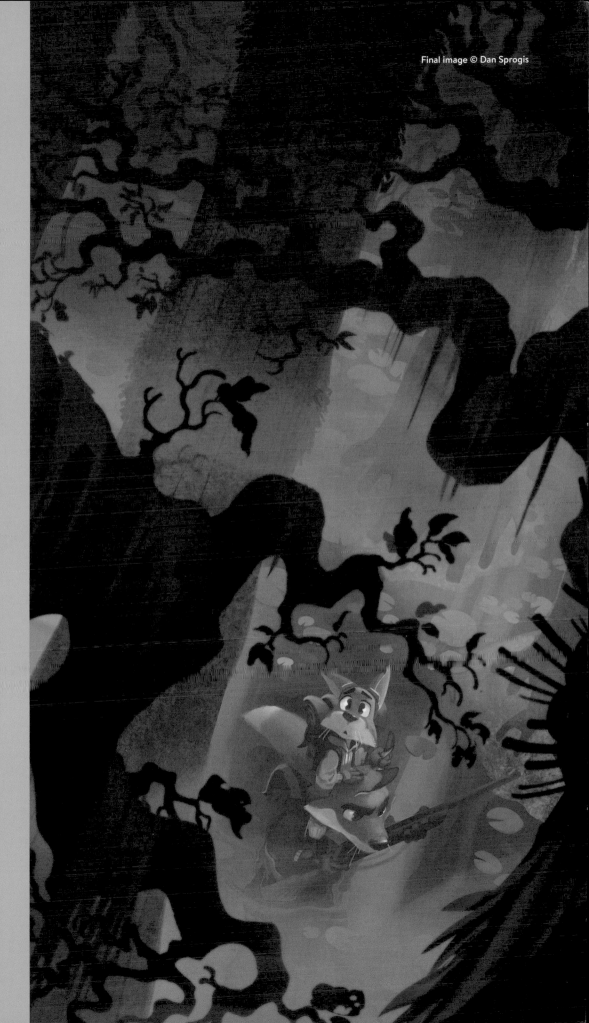

THE FOREST IS ALIVE

As a final step, adjust the colours to give your image a last bit of pop and bring every element together. The oranges of the foxes feel a little unnatural, so I add some oranges to the fog and bark of the tree to really tie the characters to the environment and create a harmonious colour scheme.

We often get used to our image after so long working on it, so seeing errors can be difficult. Mirroring your image can help you find minor problems, so give it a shot and adjust any elements that feel off. Switching your image to greyscale mode can help identify issues with colour values. As a finishing touch, add some very subtle noise or chromatic aberration to help the image feel less digital.

Right: Make the last few adjustments, but don't overdo it

CONTRIBUTORS

BENJAMIN DENKERT
Character Designer & Illustrator
instagram.com/benchpillow
Benjamin is a character designer from Germany, currently living and working in Berlin. He has a deep passion for using traditional media in his work.

AMANDA DUARTE
Partner & Creative Director
madboogie.com
Amanda is a partner and artist at Mad Boogie Creations, an outsourcing studio based in Brazil that speciliazes in illustration and visual development.

KENNY LEONCITO
Character Designer & Vis Dev Artist
kenesu.com
Kenny is a Filipino-Canadian character designer inspired by his culture. He has worked for Walt Disney Animation Studios, Netflix Animation, and more.

ANNELIESE MAK
Senior Concept Artist, Timbre Games
artstation.com/anneliese
Anneliese is an Australian illustrator and concept artist currently living in Canada, with a particular love of drawing creatures and story moments.

ILINCA MITCHELL
Freelance Illustrator
ratladyart.carrd.co
Ilinca is an artist who loves to draw wholesome animal characters going about their day in magical environments. She primarily works in watercolour and ink.

DOM 'SCRUFFY' MURPHY
Character Designer for animation
instagram.com/scruffyshenanigans
Dom is a character designer, working in feature and TV productions, a life-long sufferer of chronic doodle-itis, and an avid pun-mancer!

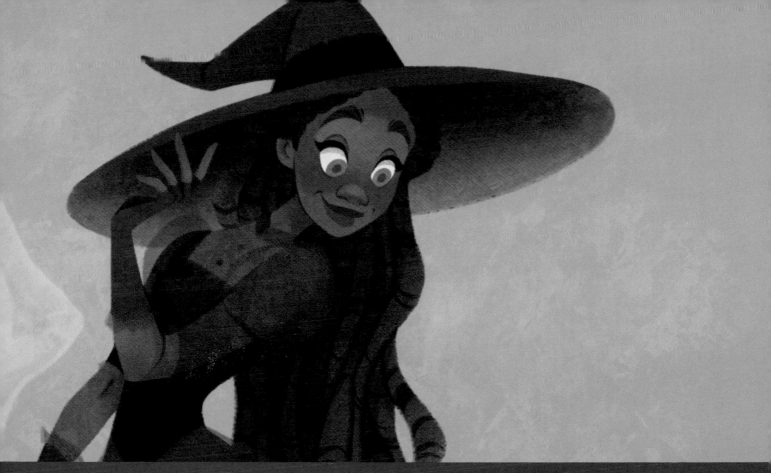

Image © Marta Garcia Navarro

MARTA GARCÍA NAVARRO
Freelance Illustrator
instagram.com/margana_mgn
Marta is a freelance artist who has illustrated several books and has been teaching Online Digital Art at a prestigious school in Spain since 2021.

NOOR SOFI
Visual Developer & Illustrator
noorsofiart.com
Noor Sofi is a visual developer and illustrator based in Los Angeles, who has worked with professional clients in both the animation and publishing industries.

DAN SPROGGIS
Art Director, Warner Bros. Animation
instagram.com/sproglebee
Dan is an artist from Hamilton, Ontario, Canada. He has worked in the animation industry for 10 years and is currently an art director at Warner Bros. Animation.

SOYEON YOO
Character Designer
soyeon-yoo.com
Soyeon Yoo is a character designer, based in LA. She has worked for Disney TV Animation, DreamWorks Animation Television, and many more.

50%

of net profits donated

TO CHARITY

In 2022, 3dtotal Publishing became successful enough to make a pledge to donate **50% of its net profits to charity**. This continues to be possible due to the incredible support from all our customers, employees, and partners. At the time of printing, we have donated over $1.45 million (USD) to charity.

We focus our giving on three charitable areas: **environmental**, **humanitarian**, and **animal welfare**. We use organizations such as Effective Altruism and Founders Pledge to guide who we help within these causes. Some ways of doing good are over 100 times more effective than others, so donating this way hugely increases the impact of our contributions.

See **3dtotal.com/charity** for full details.

3dtotalPublishing